The Planets: A Scientific Cantata
For SATB Mixed Choir
Words by John Spartan
Music by Scott Farrell

Bonus items:

Sonnet 75 (Words by Edmund Spenser)

Opera selections
- "Your views on love" from *Lindarella's List*
- "Music and Mirth", "Since the World Began" from *Two Merry Monarchs*
- Art Song from *Popocateptyl*

Copyright 2006, 2014. All rights reserved. Printed in the U.S.A.
ISBN: 978-1-312-43658-9

Introduction

John Spartan and I wrote "The Planets" for a music composition contest that we entered in the beginning of 2006. I wrote the music in two days that January. Spartan patterned his lyrics after Ogden Nash, an American poet of humorous poetry and comic verse. The rhymes are intentionally unconventional and silly (i.e. "mercury/quirk your e-"), and are meant to be fun and childlike. Yet for each planet's lyrics, quick facts are presented, not fiction. So it's educational, too!

We did not win the competition, and so the work has never been performed or published until this volume was created. It is a programme piece, intended for mixed choirs, and some passages may be allotted to soloists if desired. The planet "Saturn" may be split between two female voices who form a duet at the close, and the "Neptune" may be sung by one male voice. In no cases should this work be performed with instrumentation other than piano accompaniment.

The planet "Pluto" was not discarded until later in 2006, when the International Astronomical Union decided that Pluto is actually a dwarf planet. Yet Spartan and I left 'Pluto' in our work. Without it, the ending would make no sense (not to mention end anti-climatically), and since many people still think of Pluto as a planet, we address the issue and pick a side during the course of the lyrics. For this reason, Pluto should stay in the composition and let the audience decide for themselves if it really qualifies as a planet.

The low bass note that occurs repeatedly at the beginning and ending of the cantata is meant to represent the alleged B-flat that the universe sounds, but so low that no one can hear it. Whether its existence is fact or fancy, it is included to represent the vastness of space.

I hope you and your choir enjoy "The Planets: A Scientific Cantata". Also included in this volume is my "Sonnet 75", and selections from two operas I wrote with Spartan, as well as one from *Two Merry Monarchs.* These songs need not be included with performances of "The Planets", but are presented here to meet Lulu.com's minimum page requirement, as well as give samples of other works I have published.

- Scott Farrell
August 14, 2014

Contents

Exposition .1

"Mercury" .2

"Venus" . 4

"Earth" .7

"Mars" . 9

"Jupiter" .13

"Saturn" . 19

"Uranus" .20

"Neptune" .24

"Pluto" . 25

Coda . 29

Bonus Items
Sonnet 75 (*Words by Edmund Spenser*) . 31
"Your views on love", from *Lindarella's List* . 35
"Music and Mirth", from *Two Merry Monarchs* .45
Art Song, from *Popocateptyl* . 53

The Planets: A Scientific Cantata

Lyrics by John Spart
Music by Scott Farrel

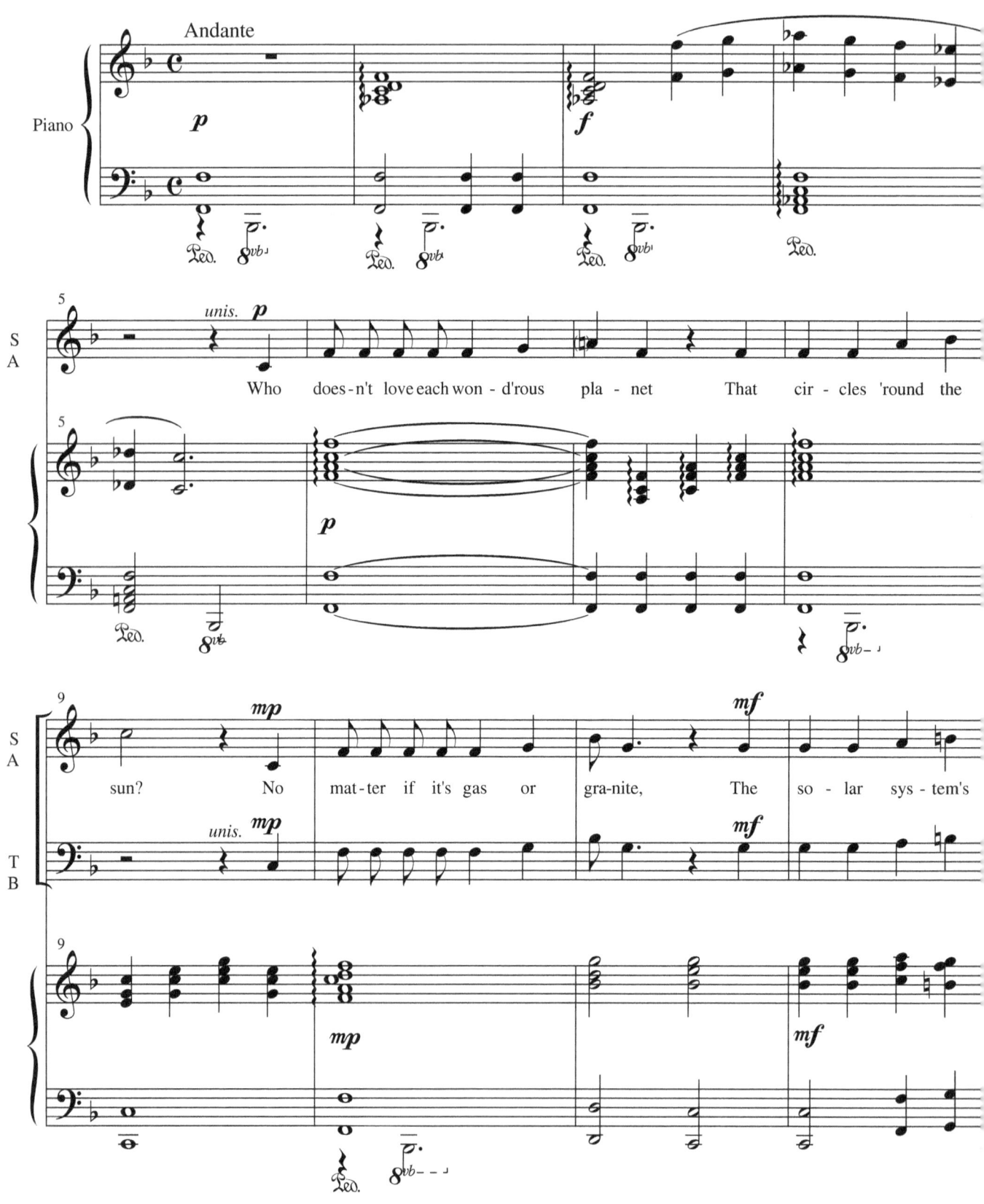

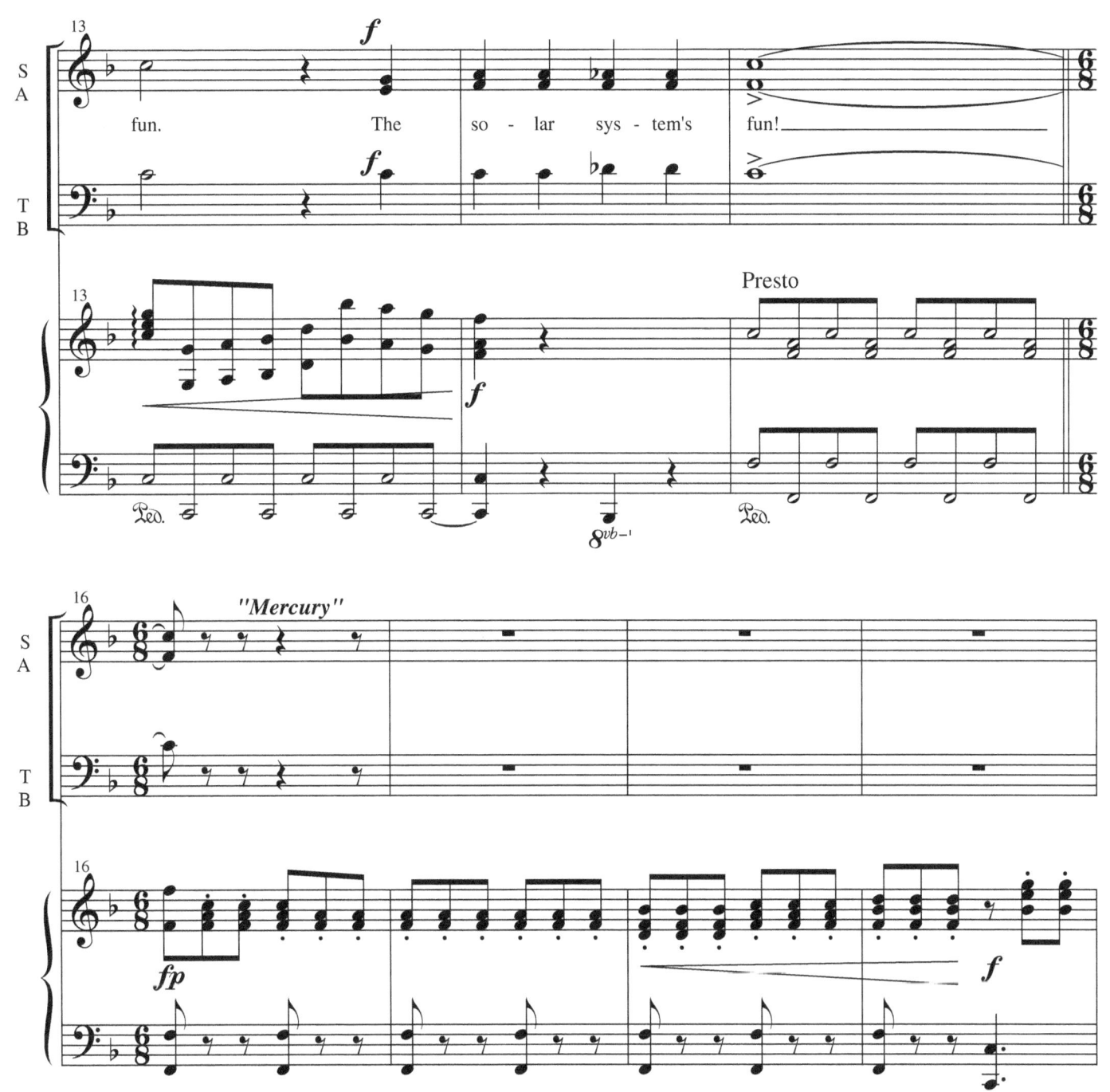

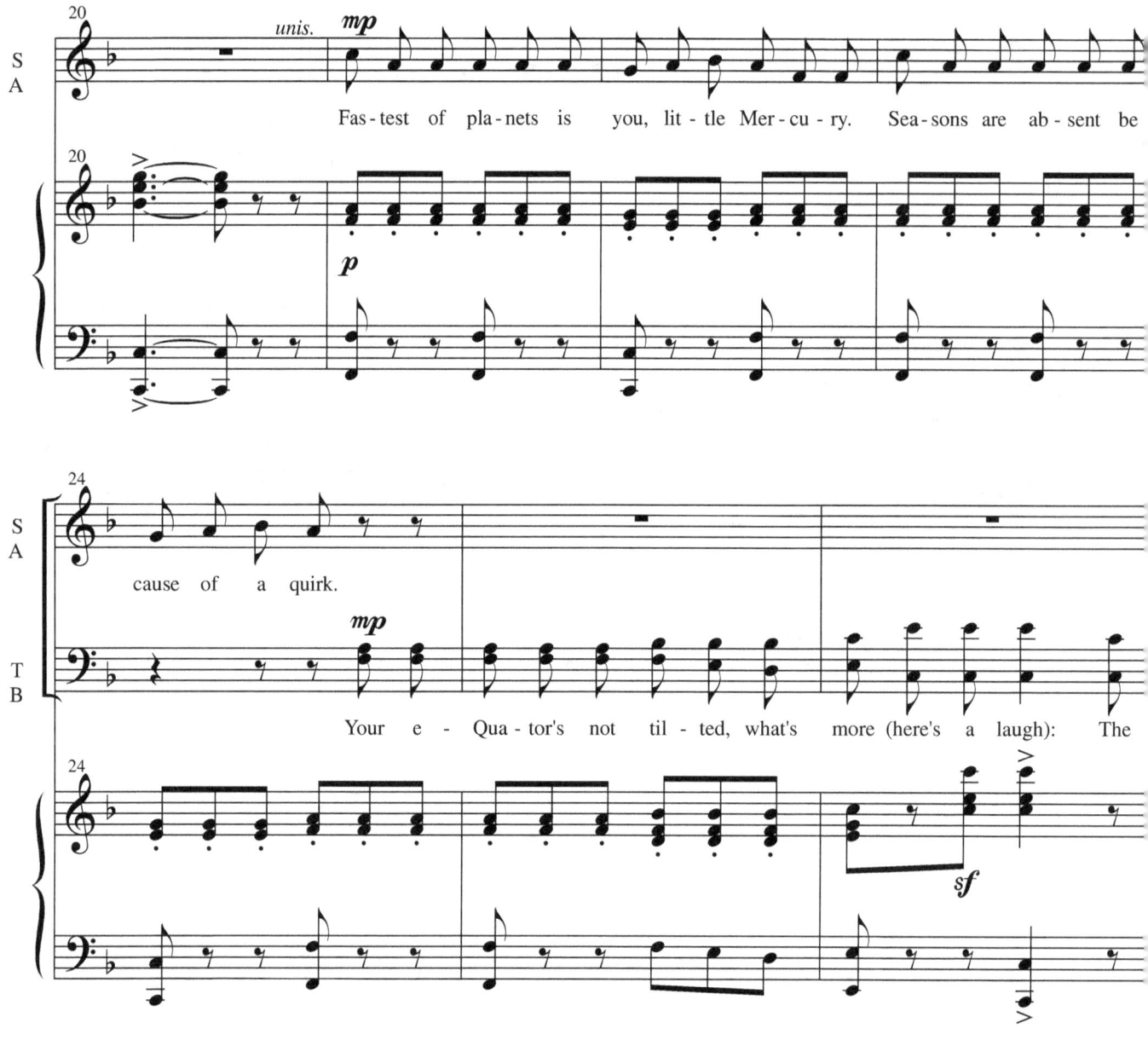

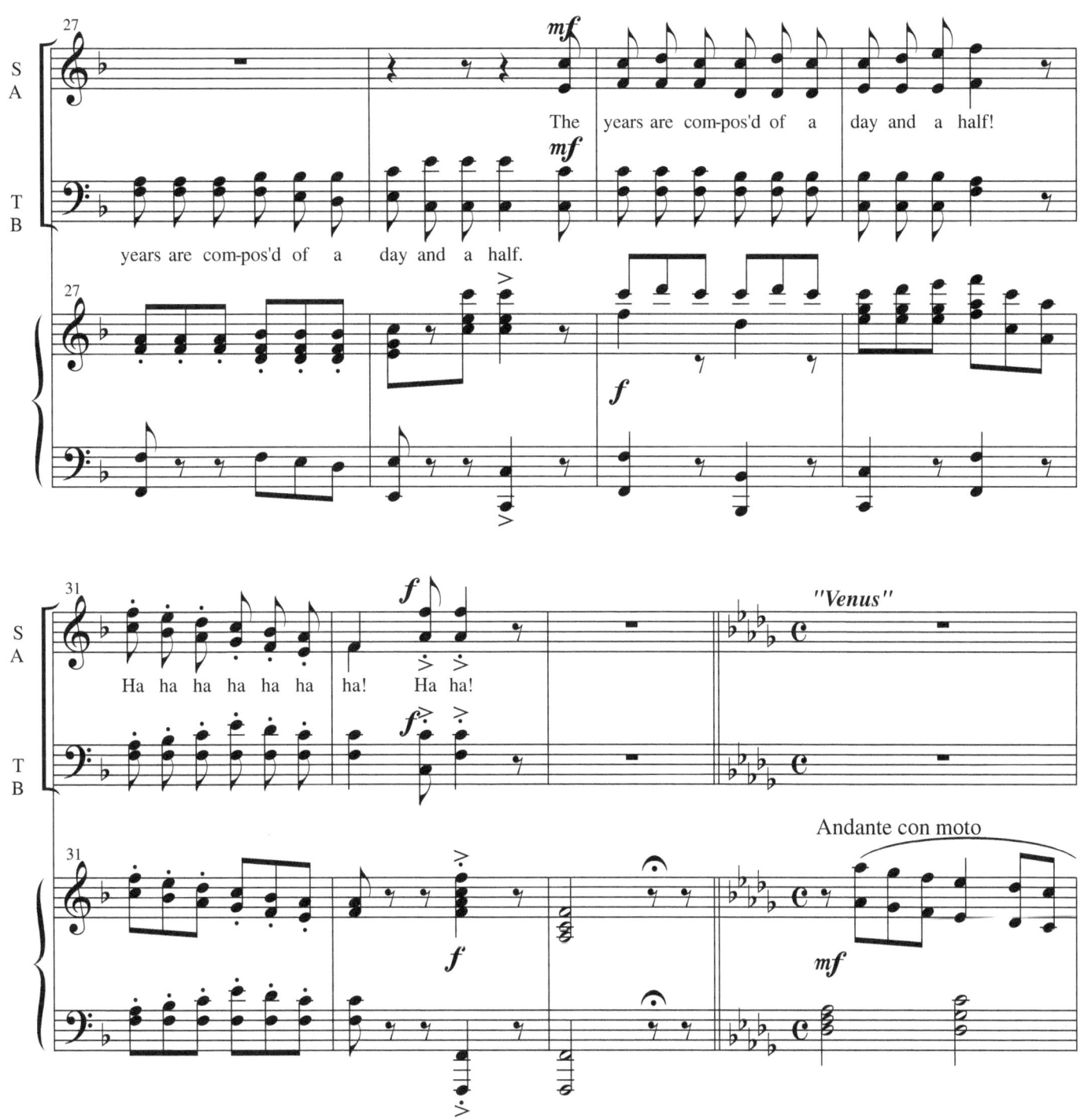

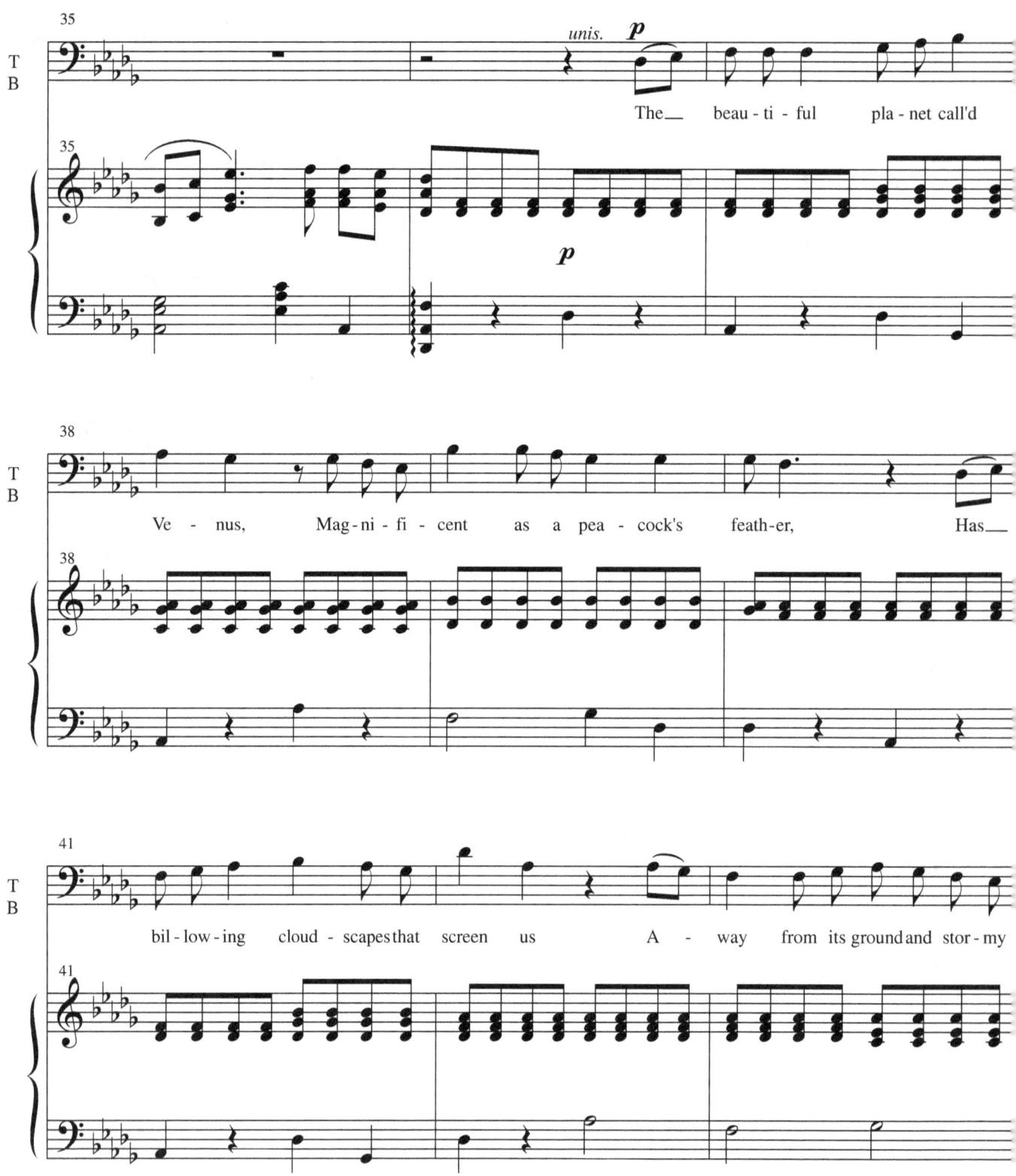

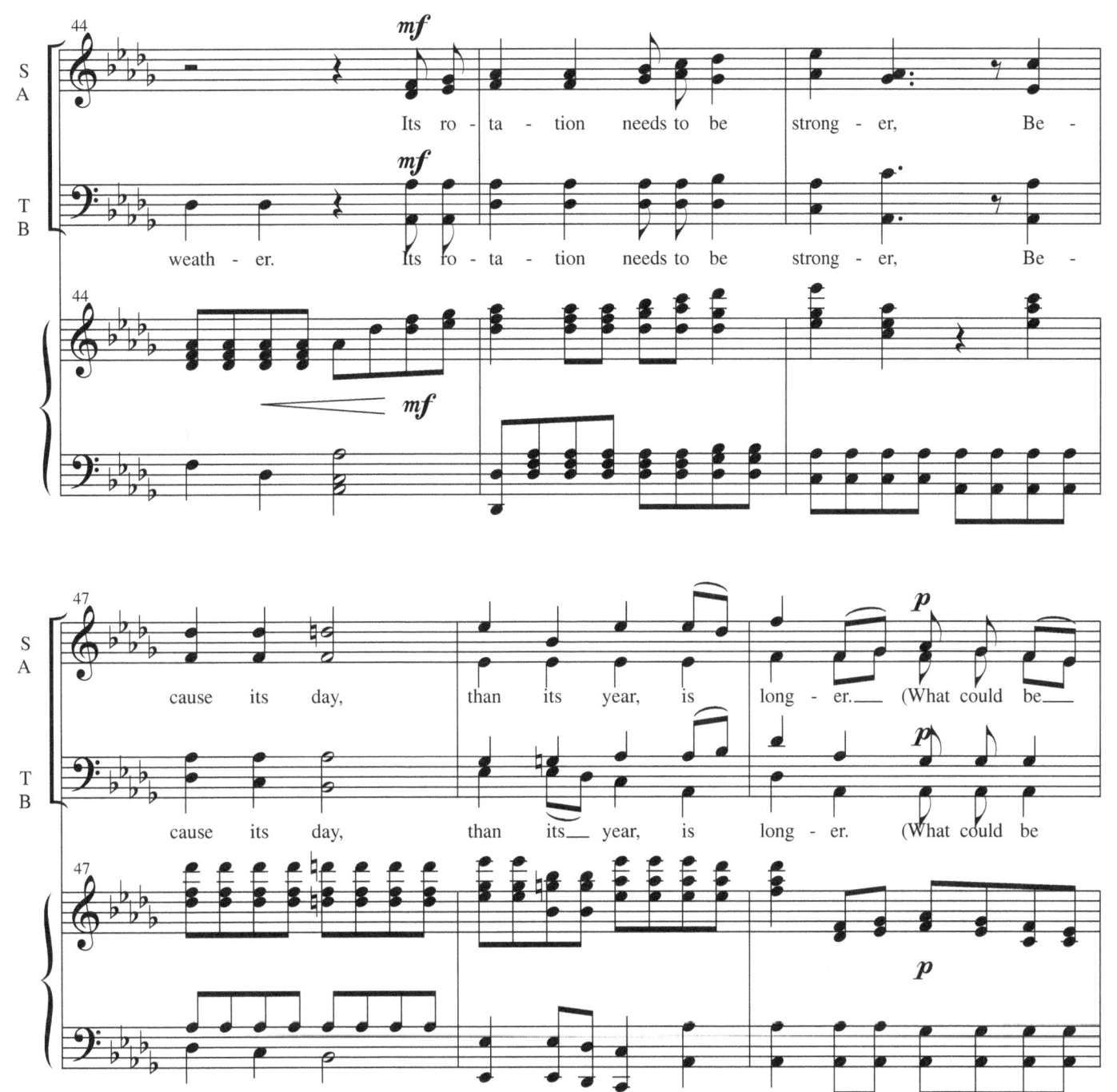

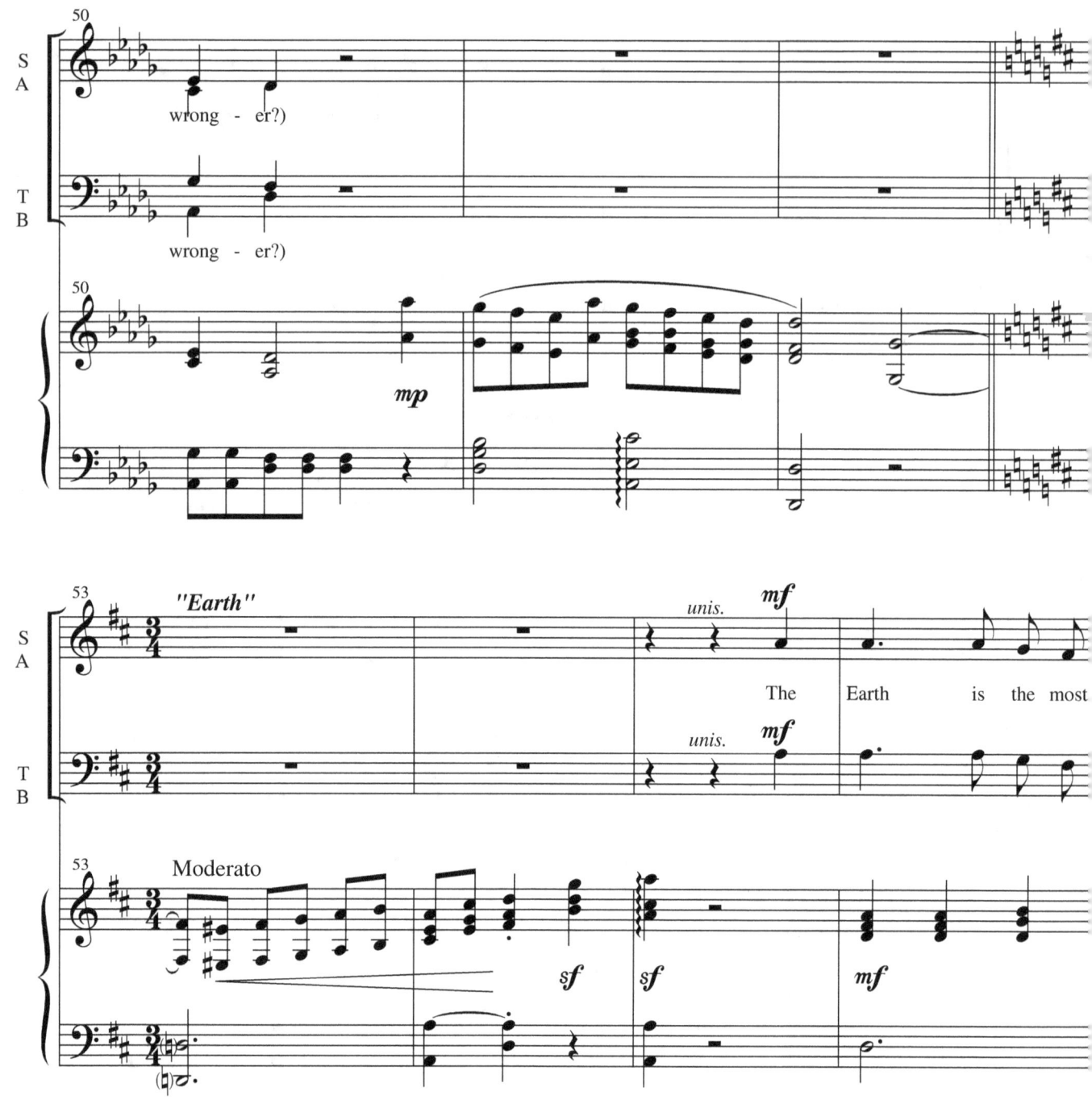

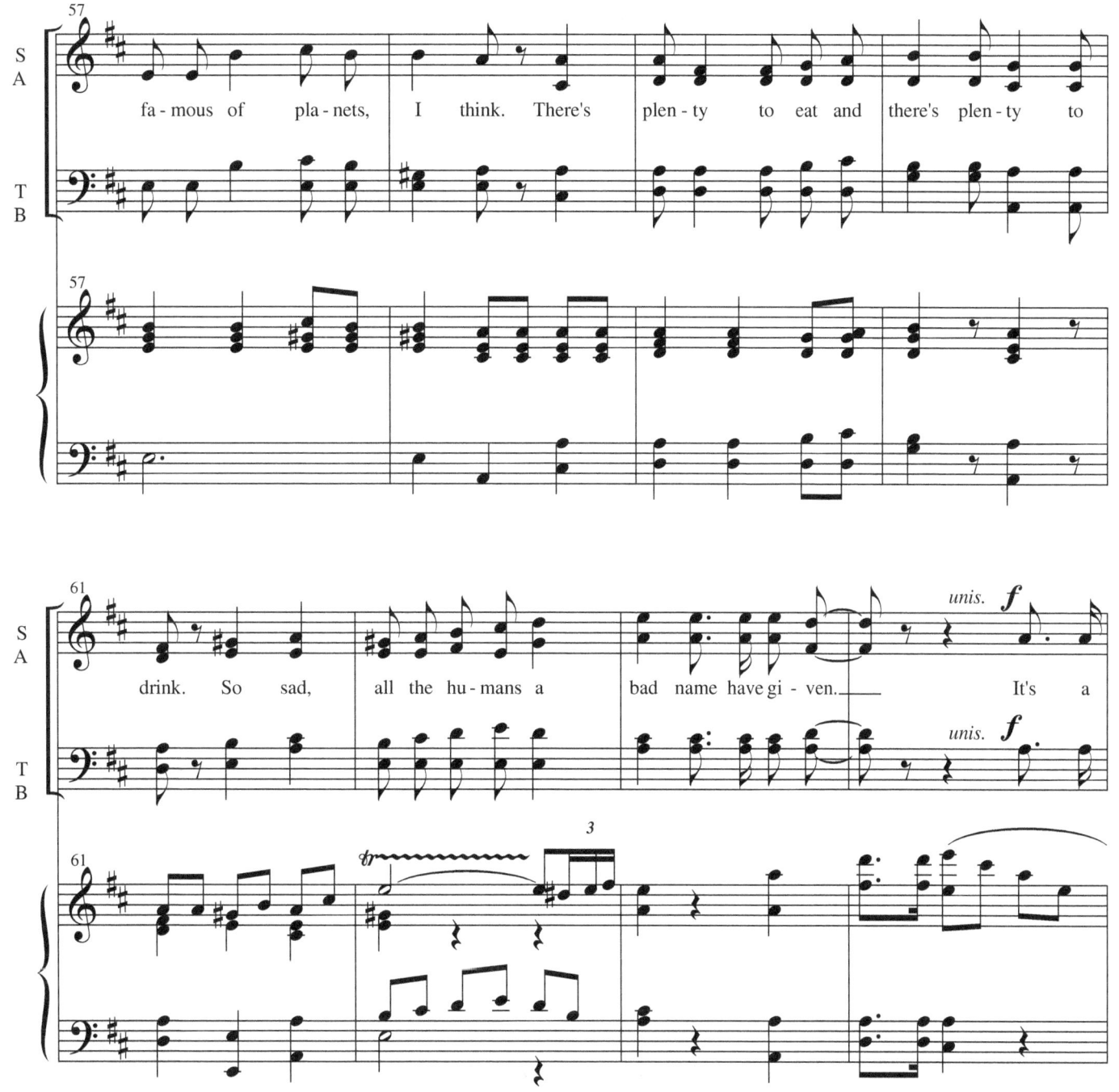

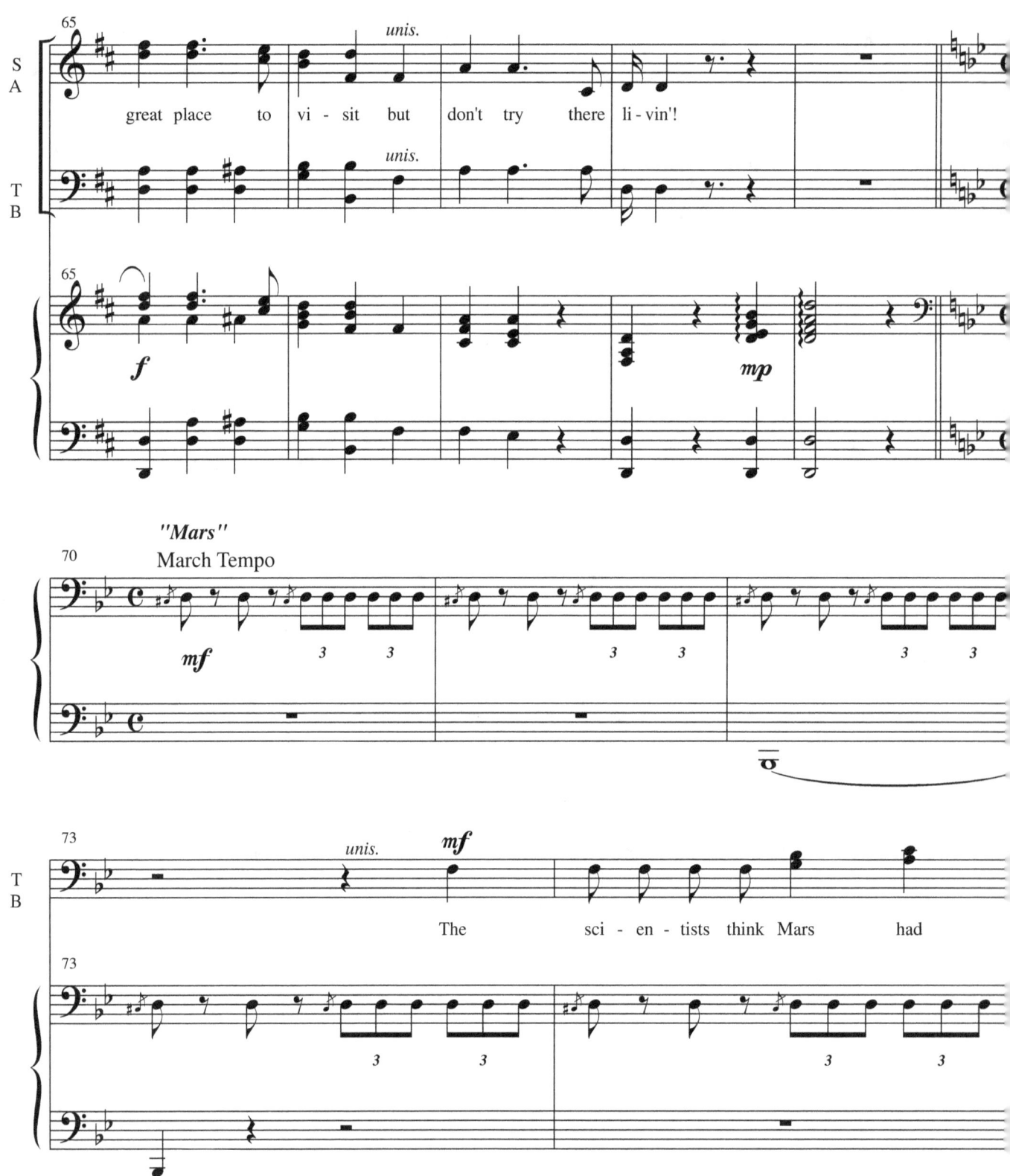

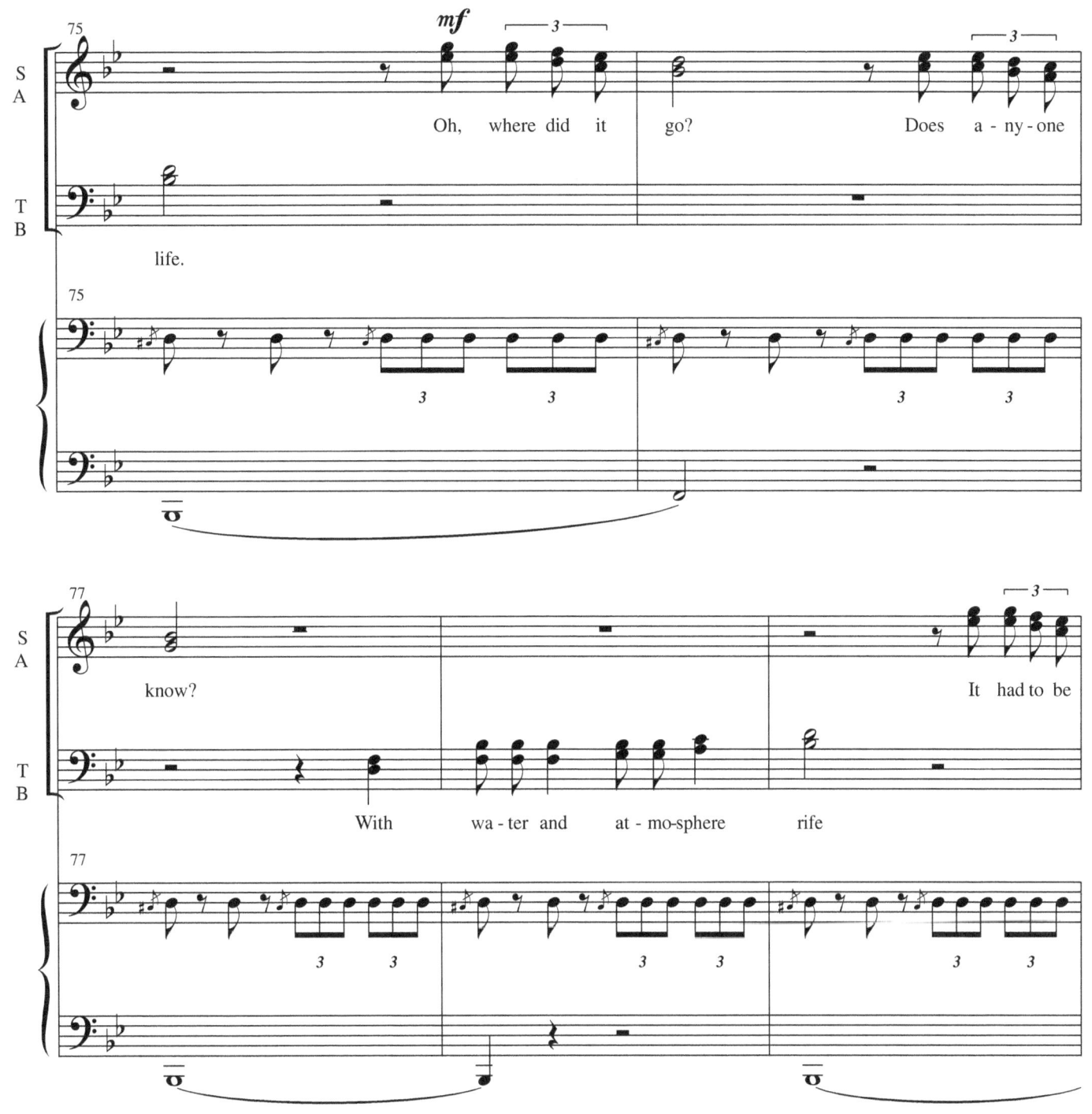

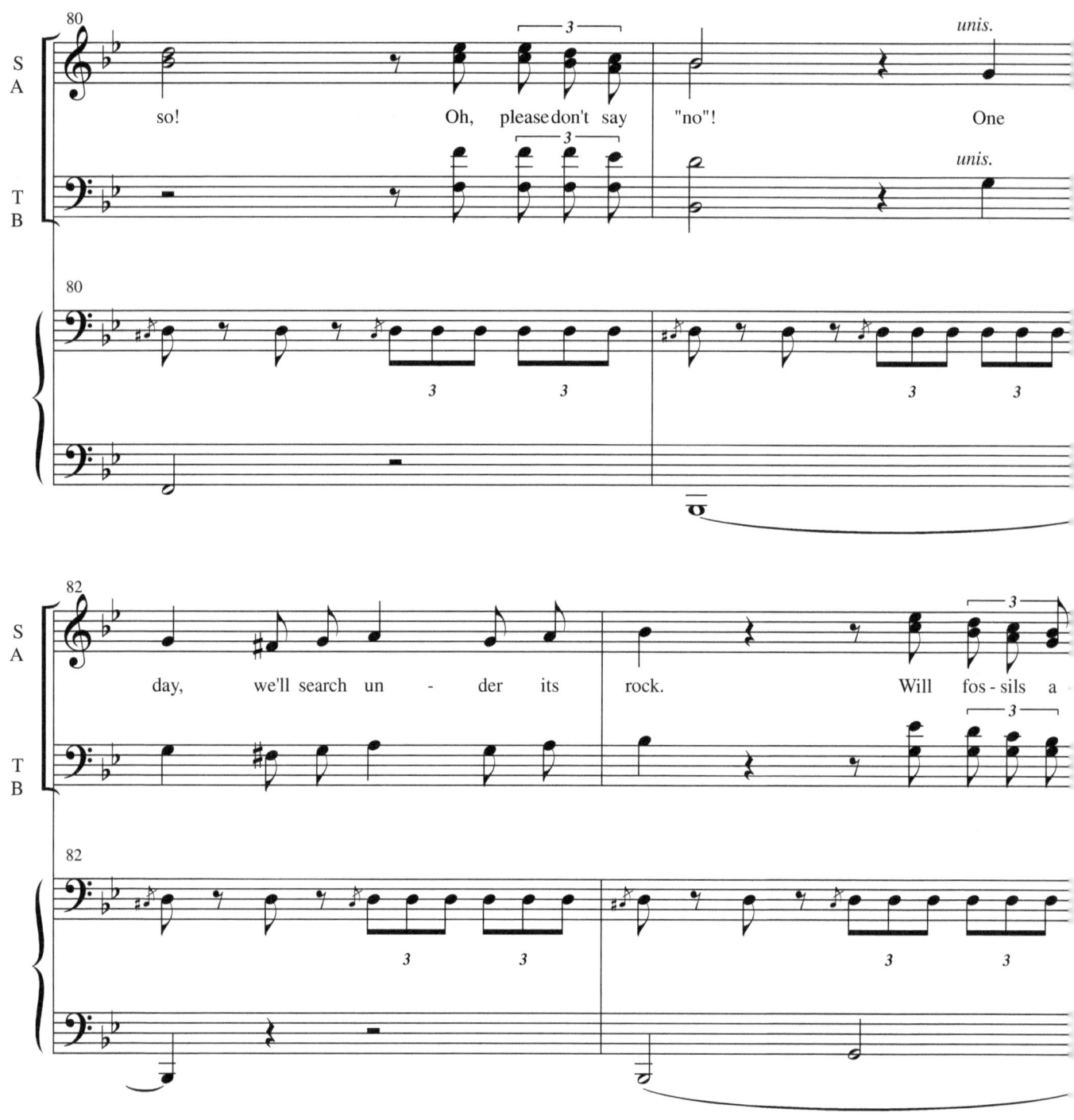

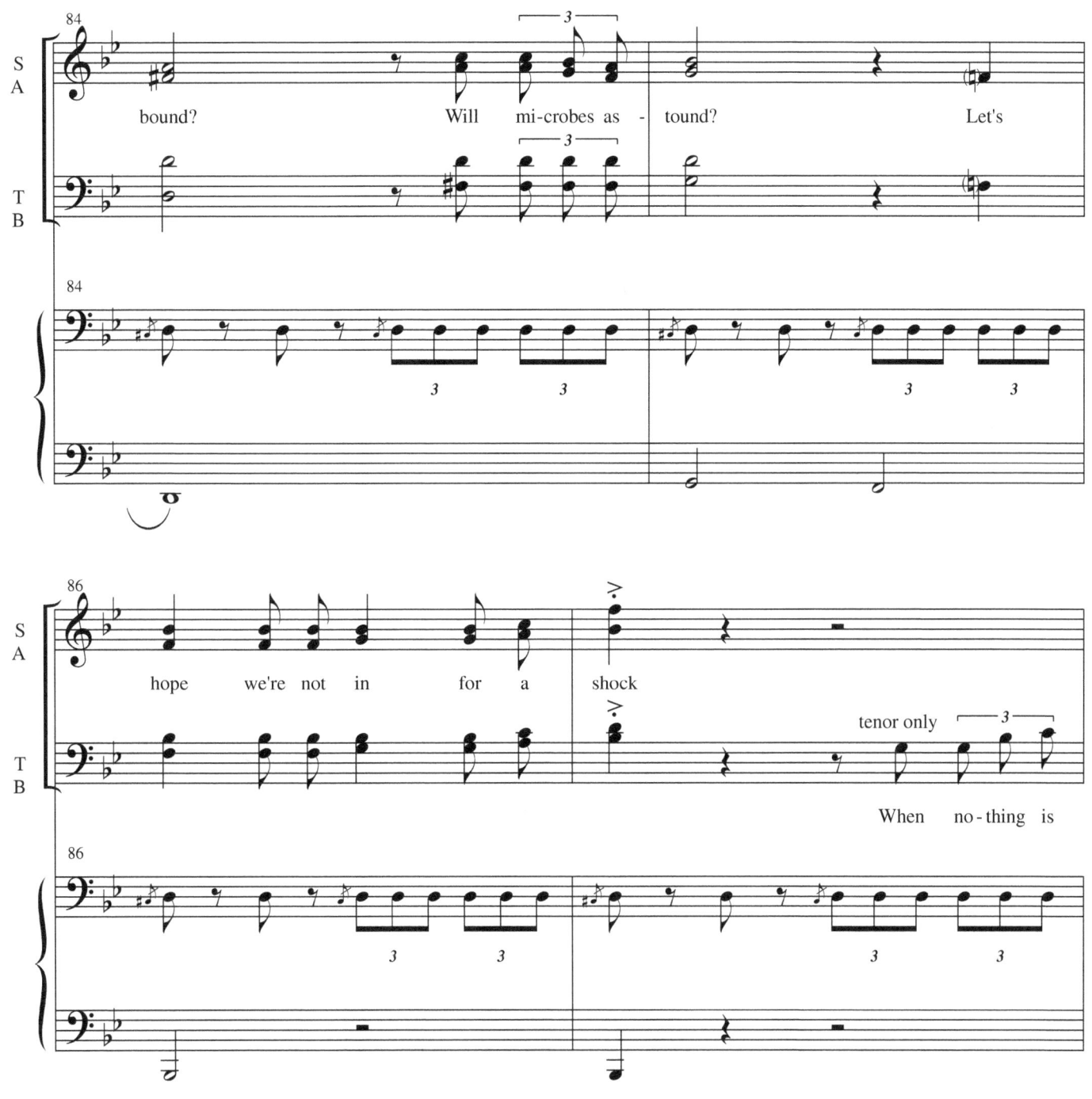

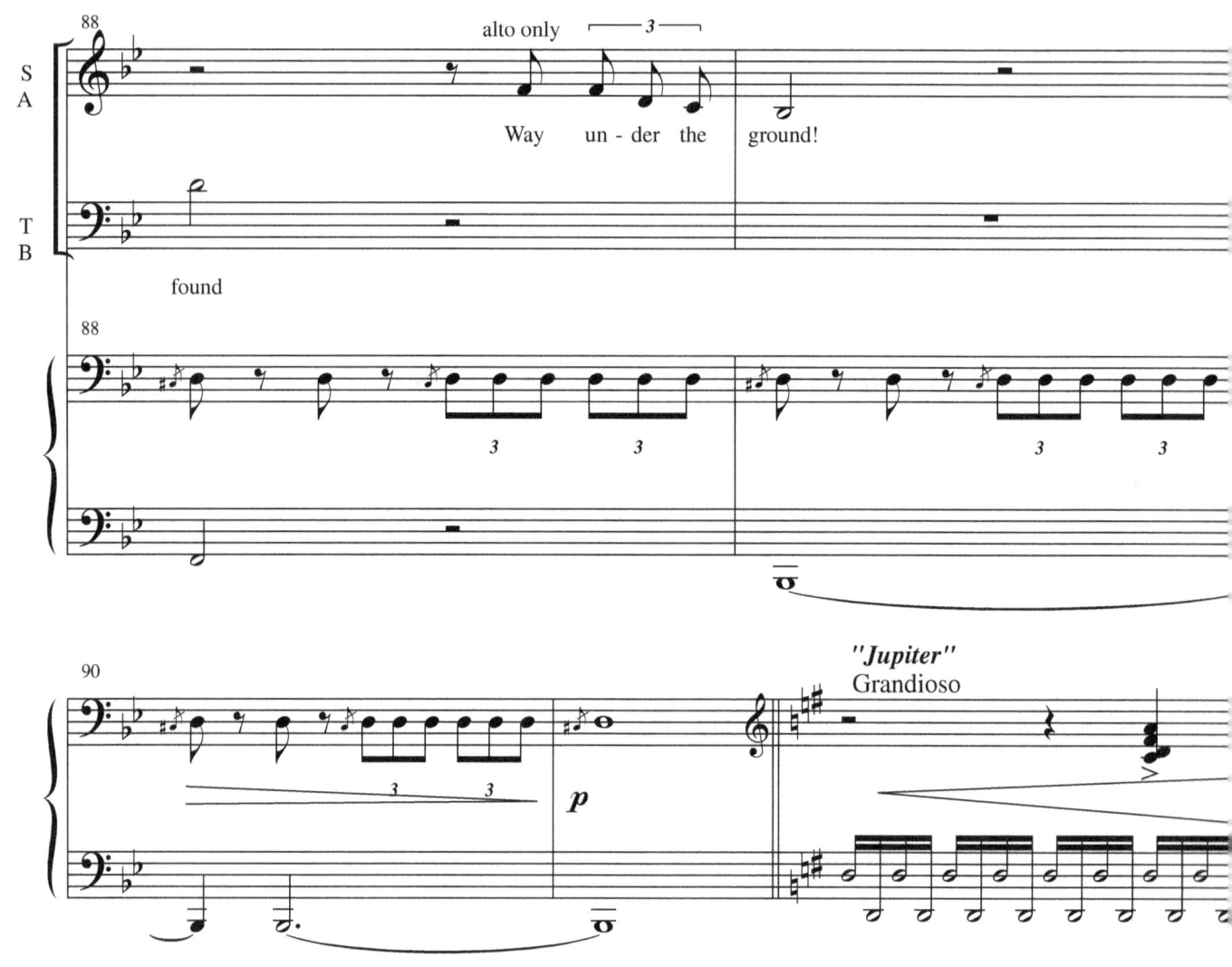

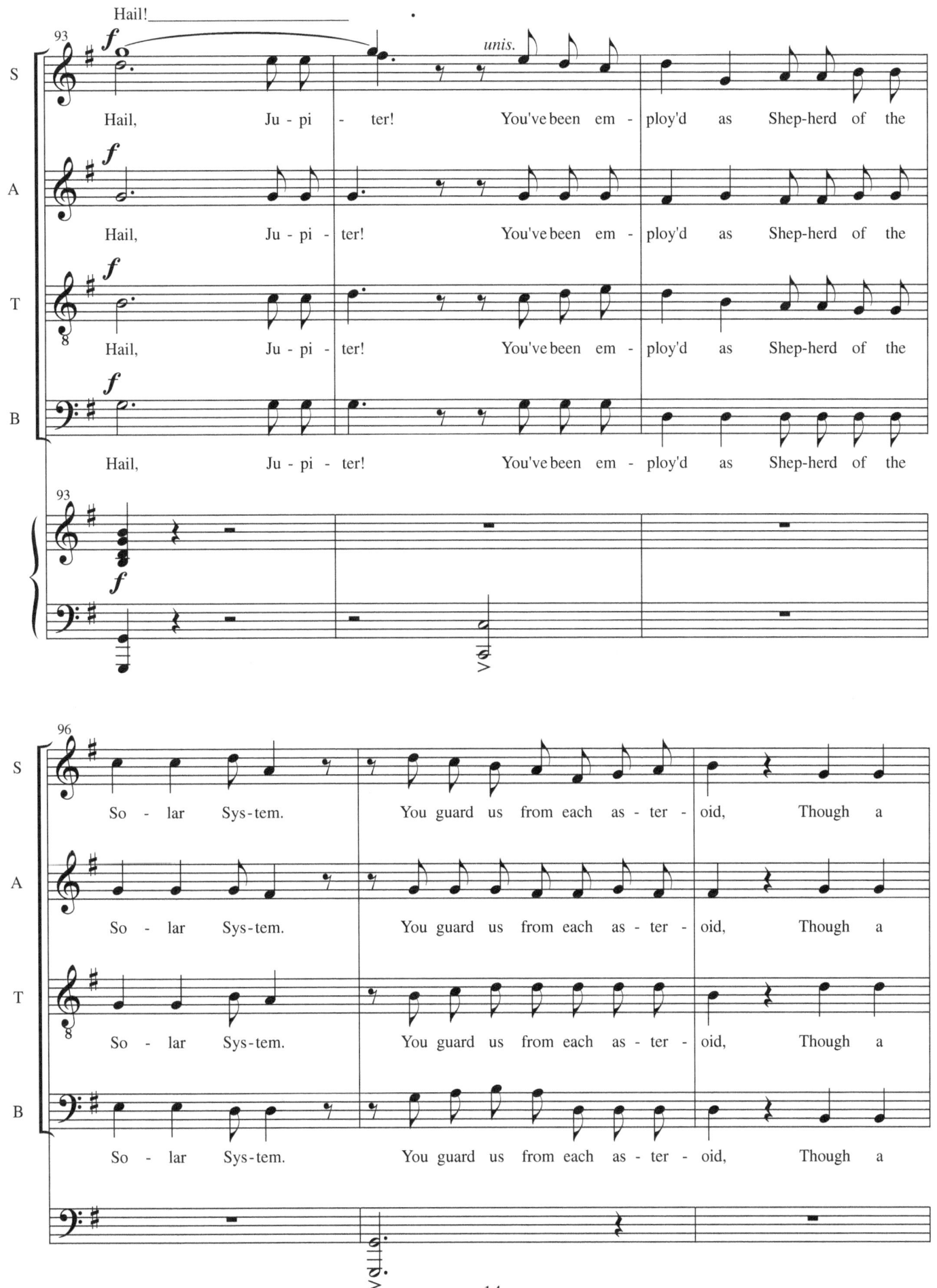

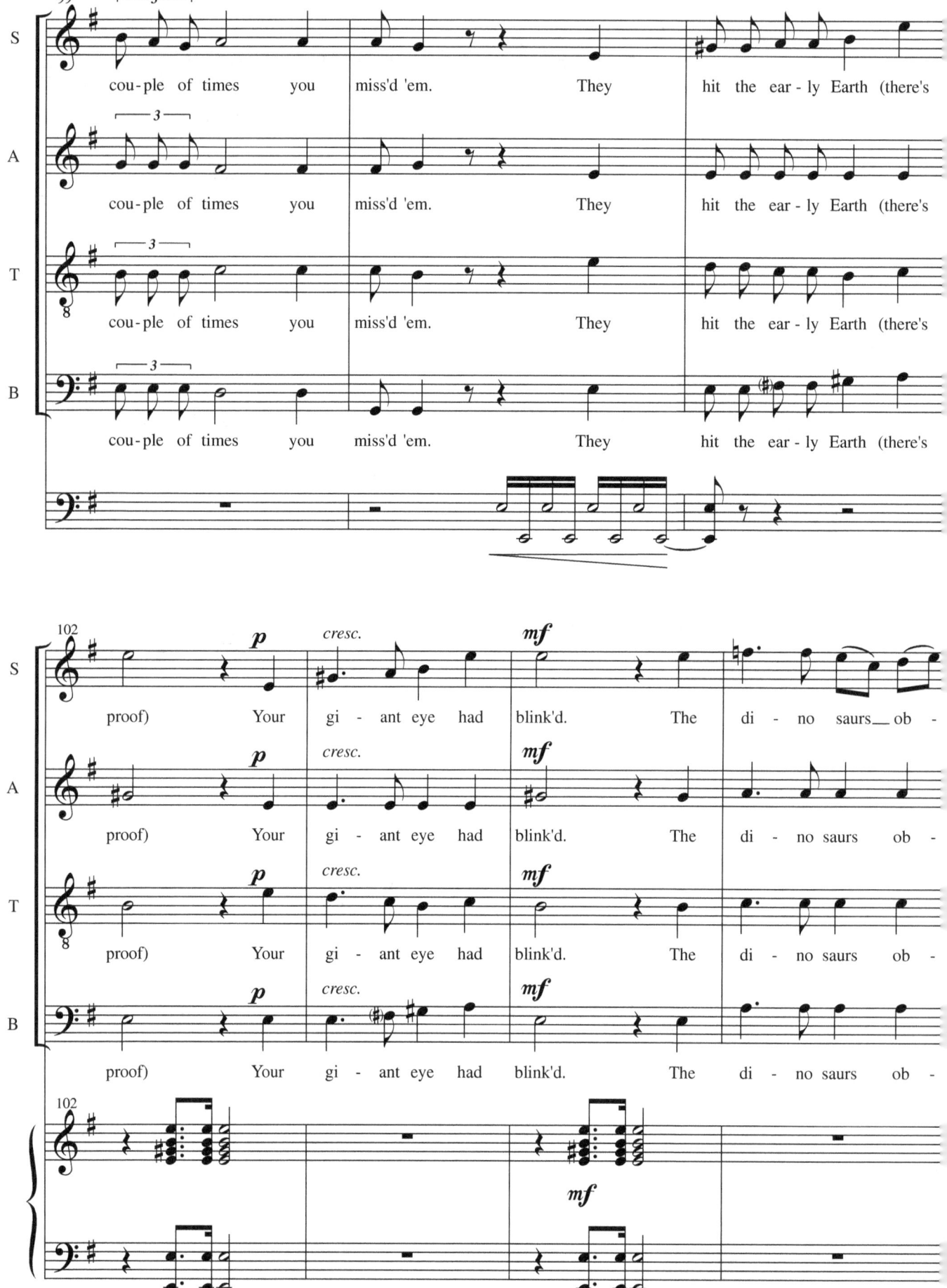

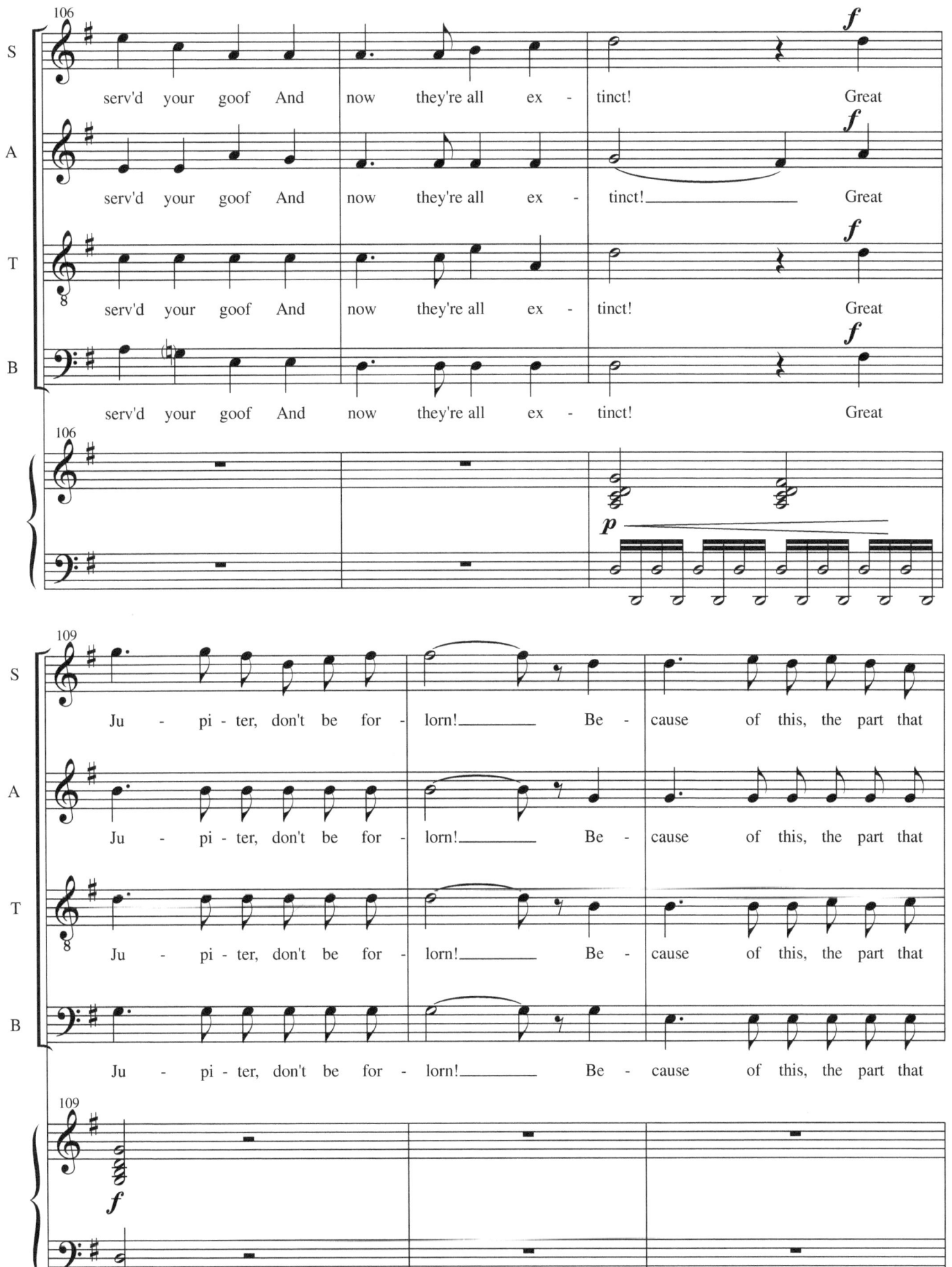

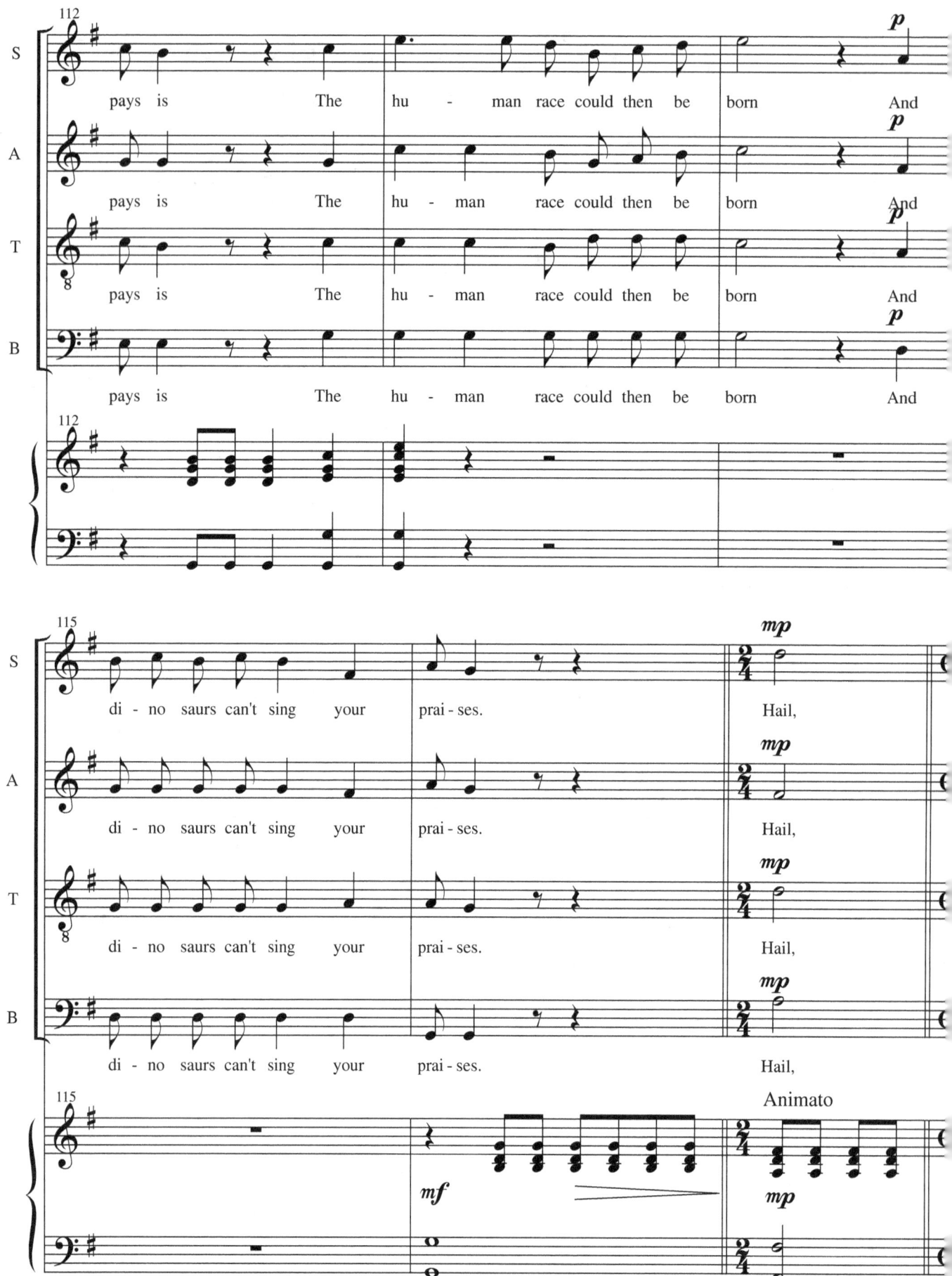

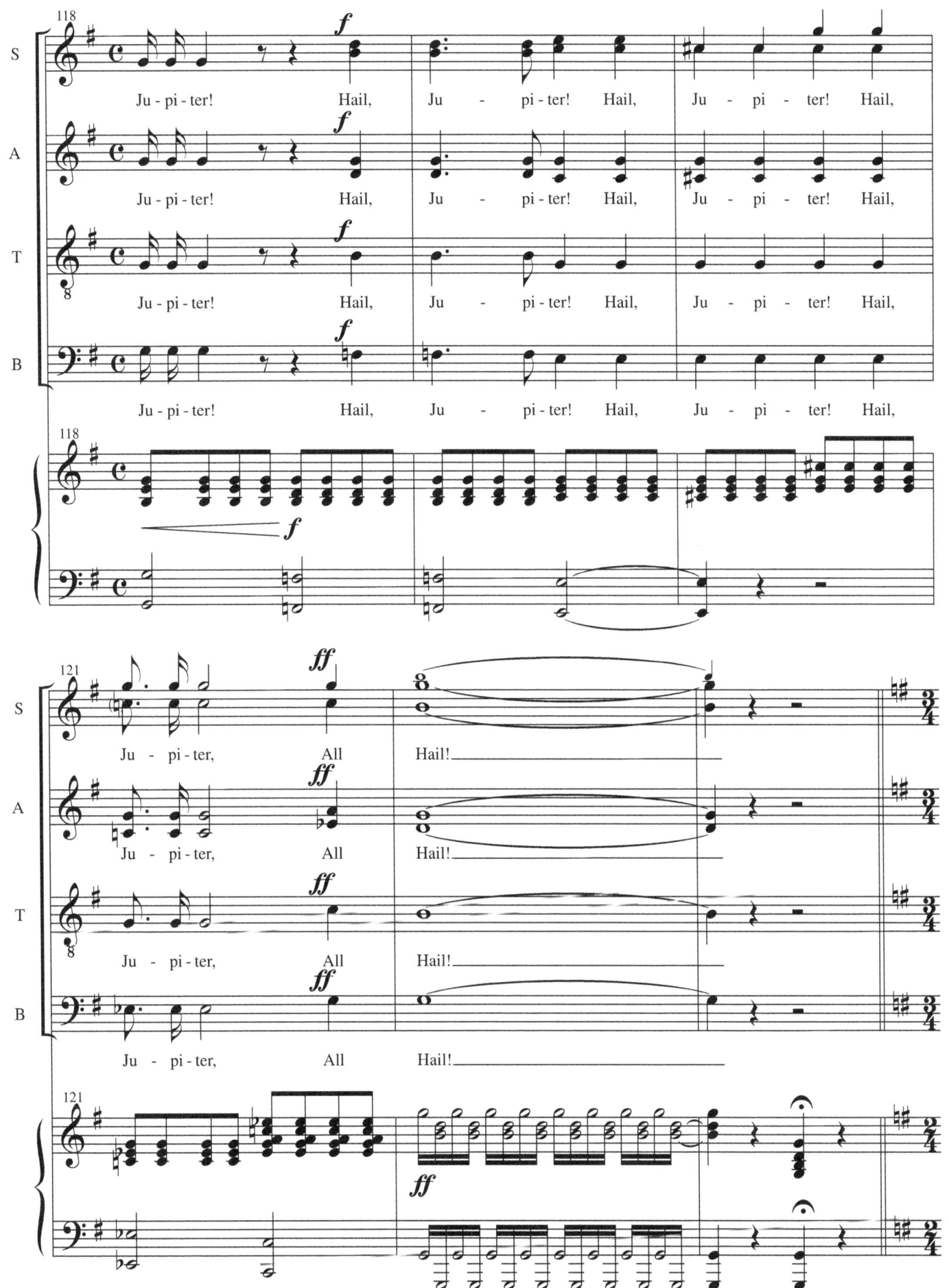

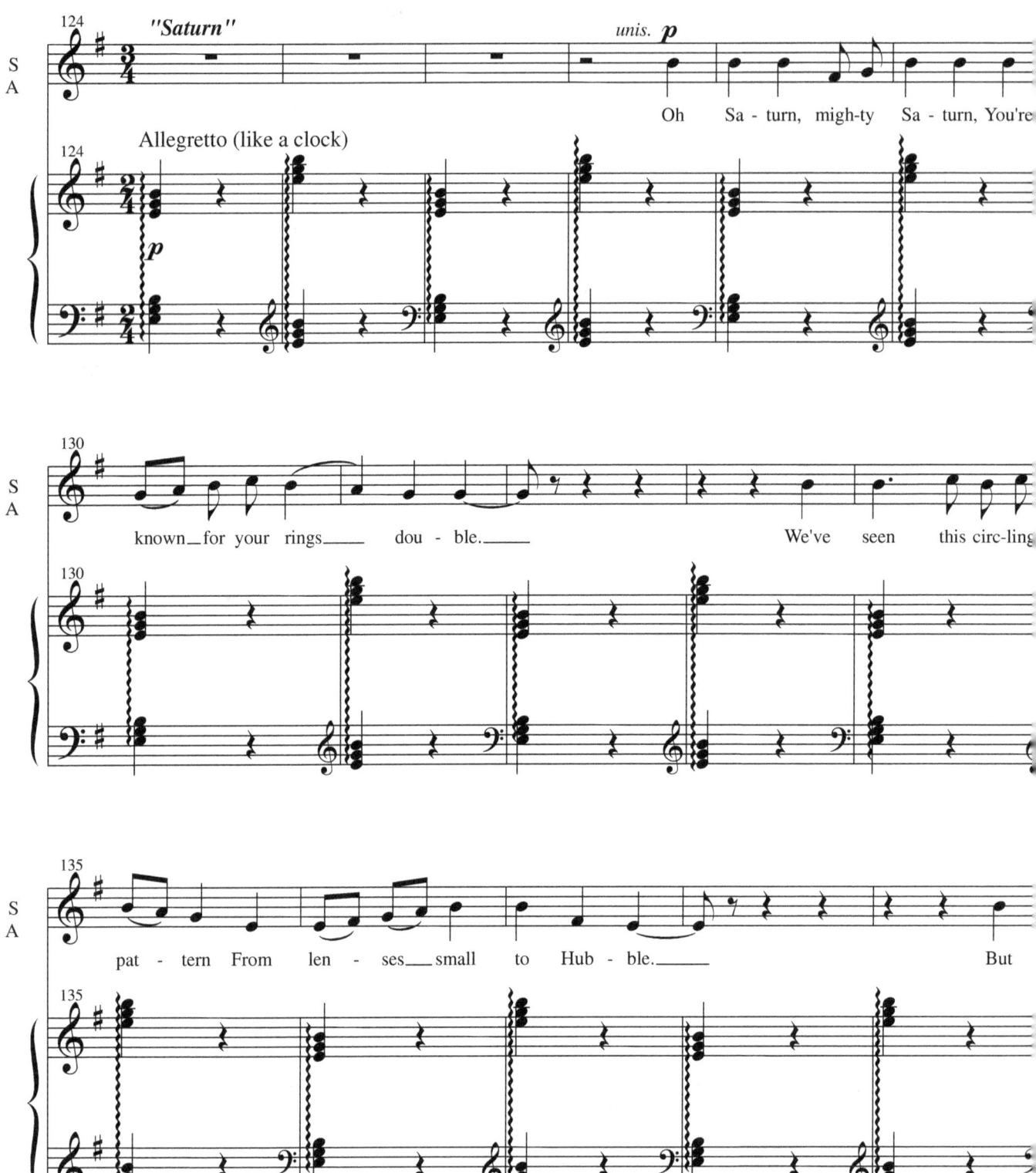

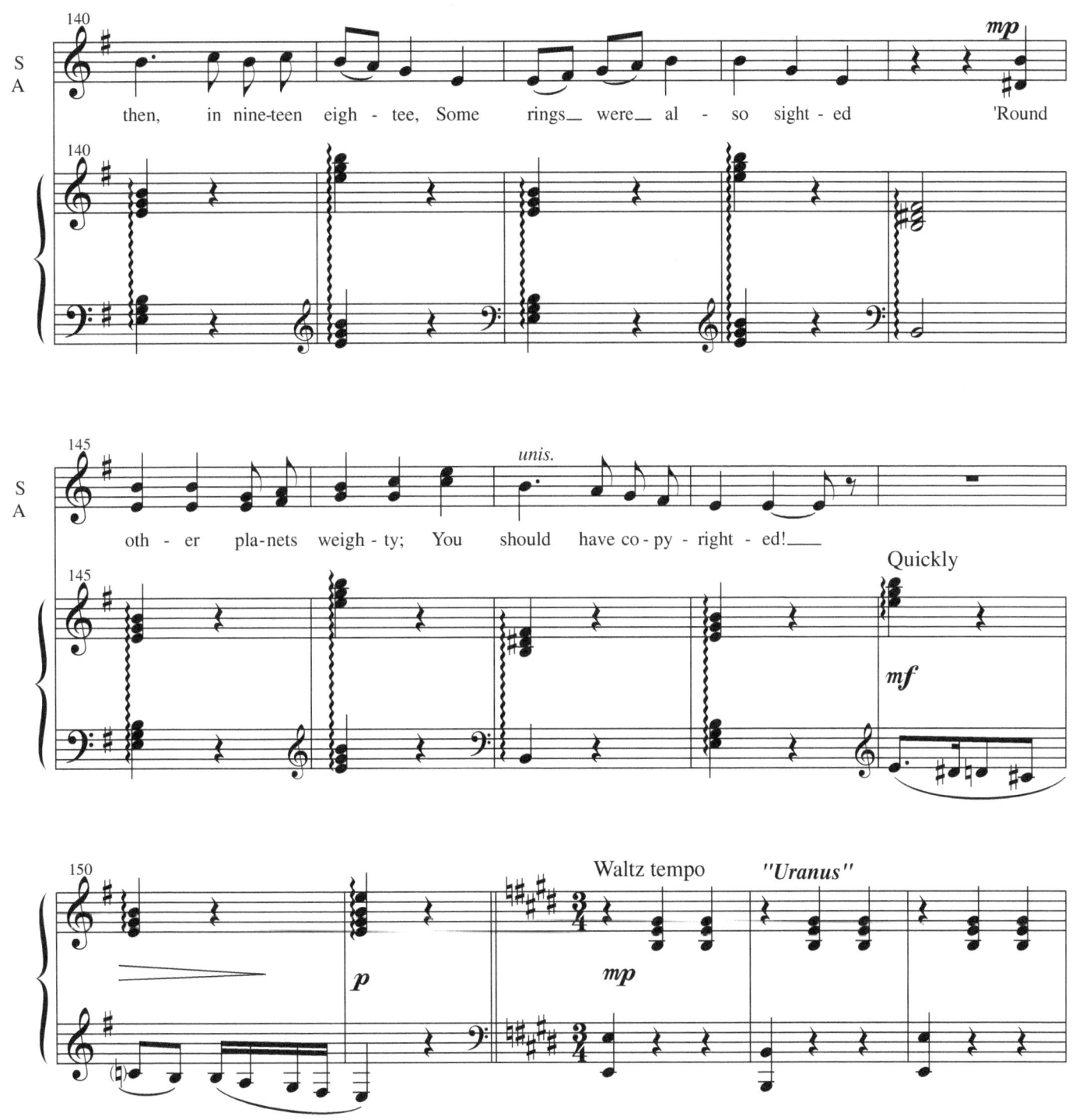

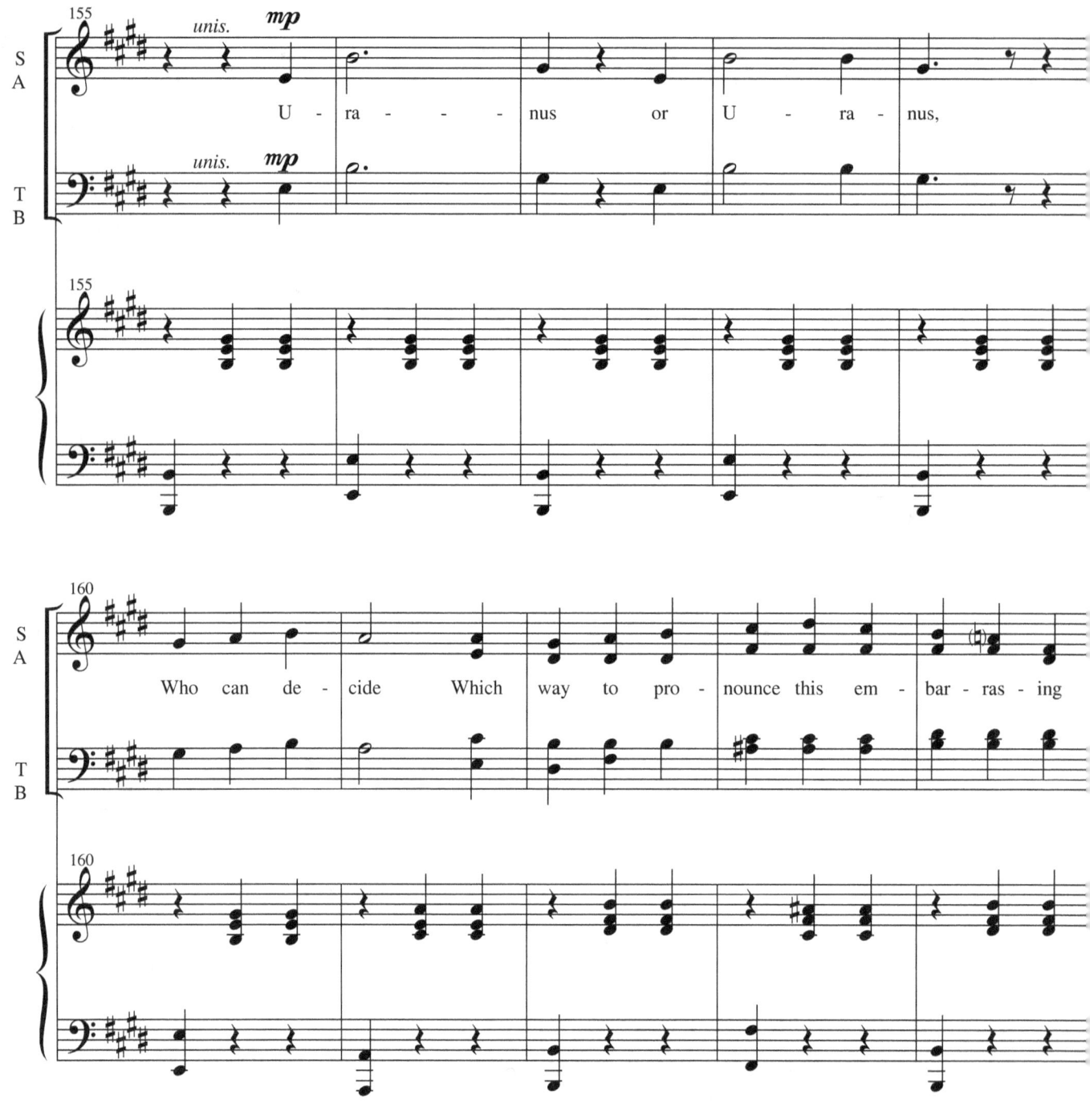

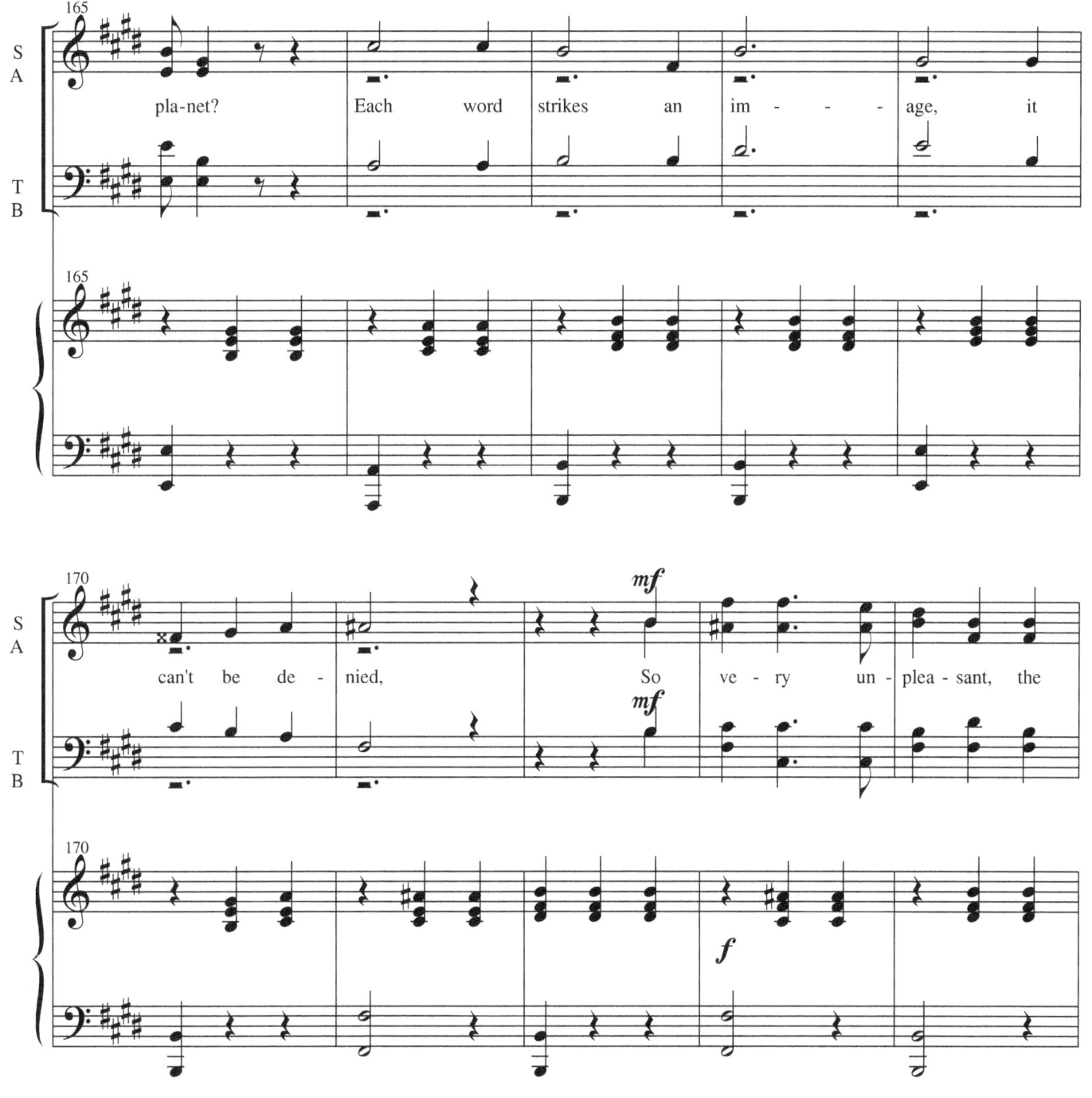

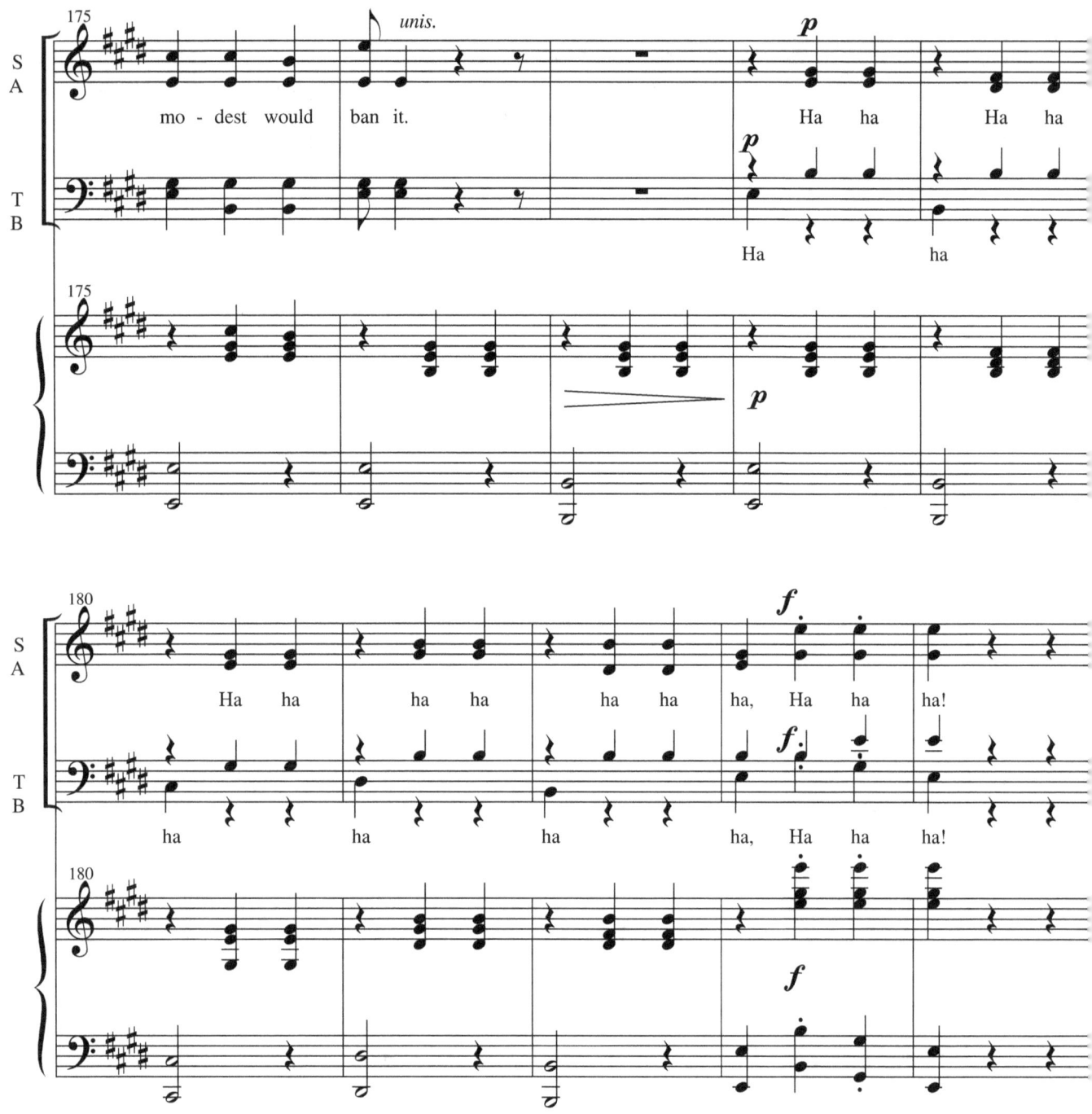

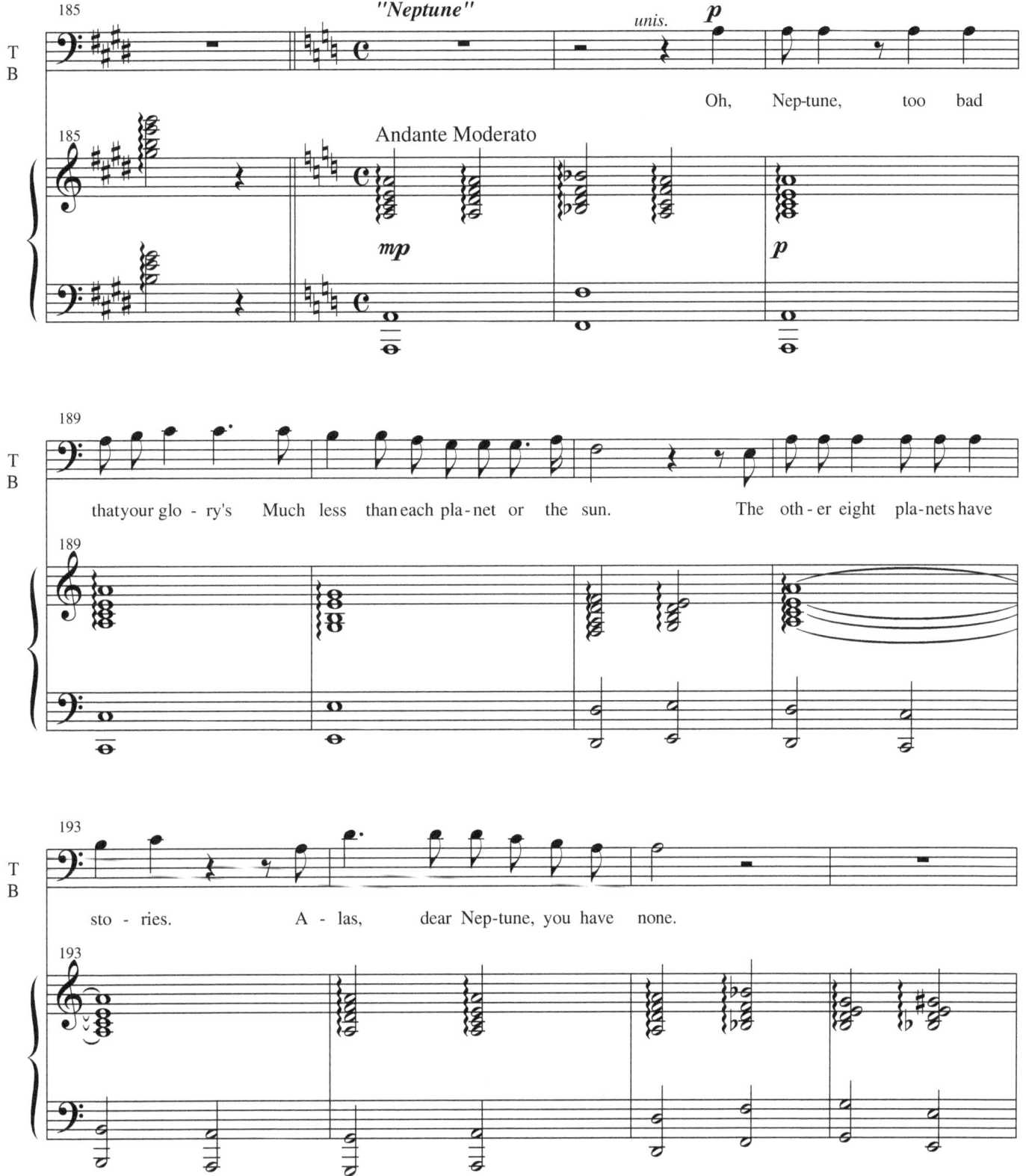

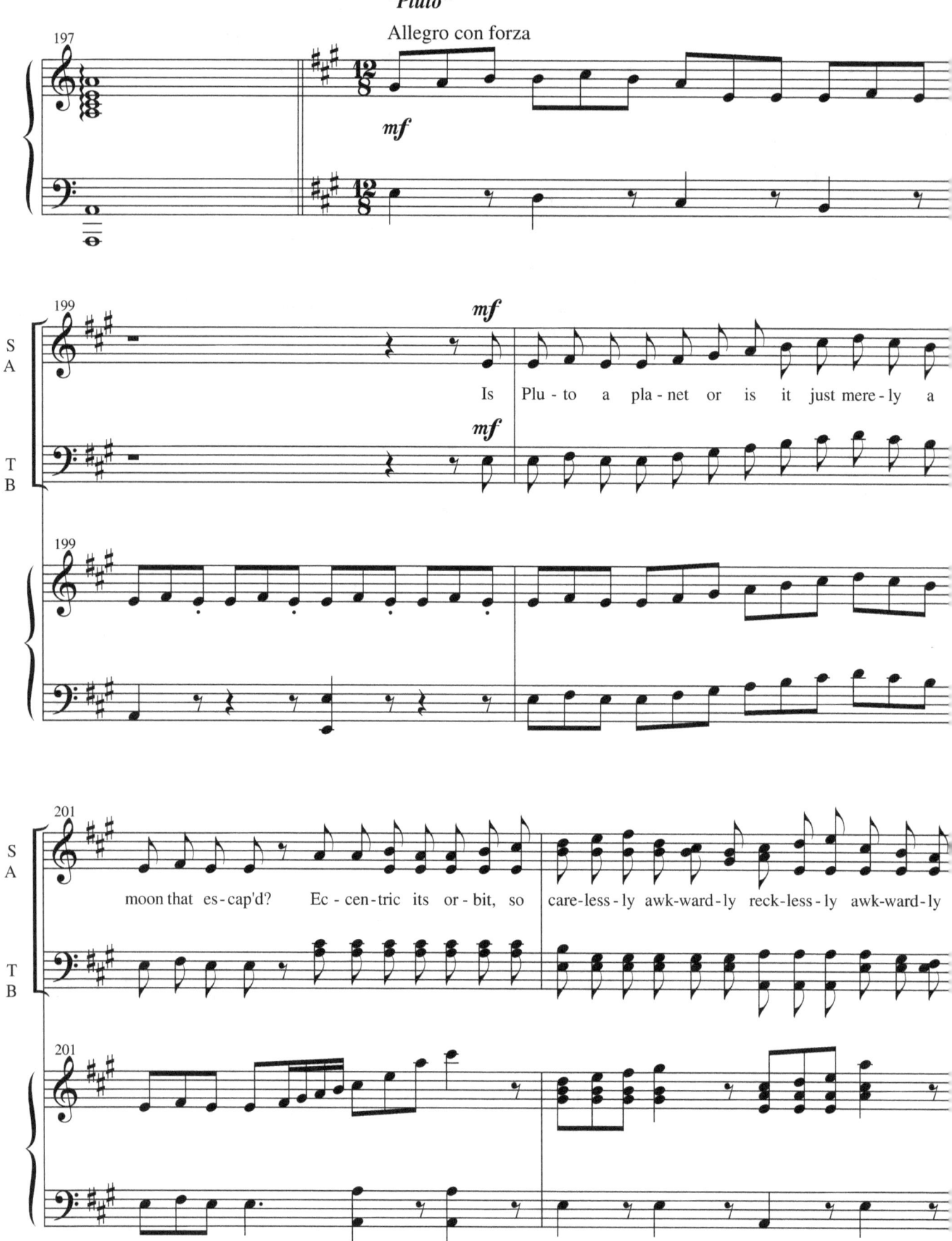

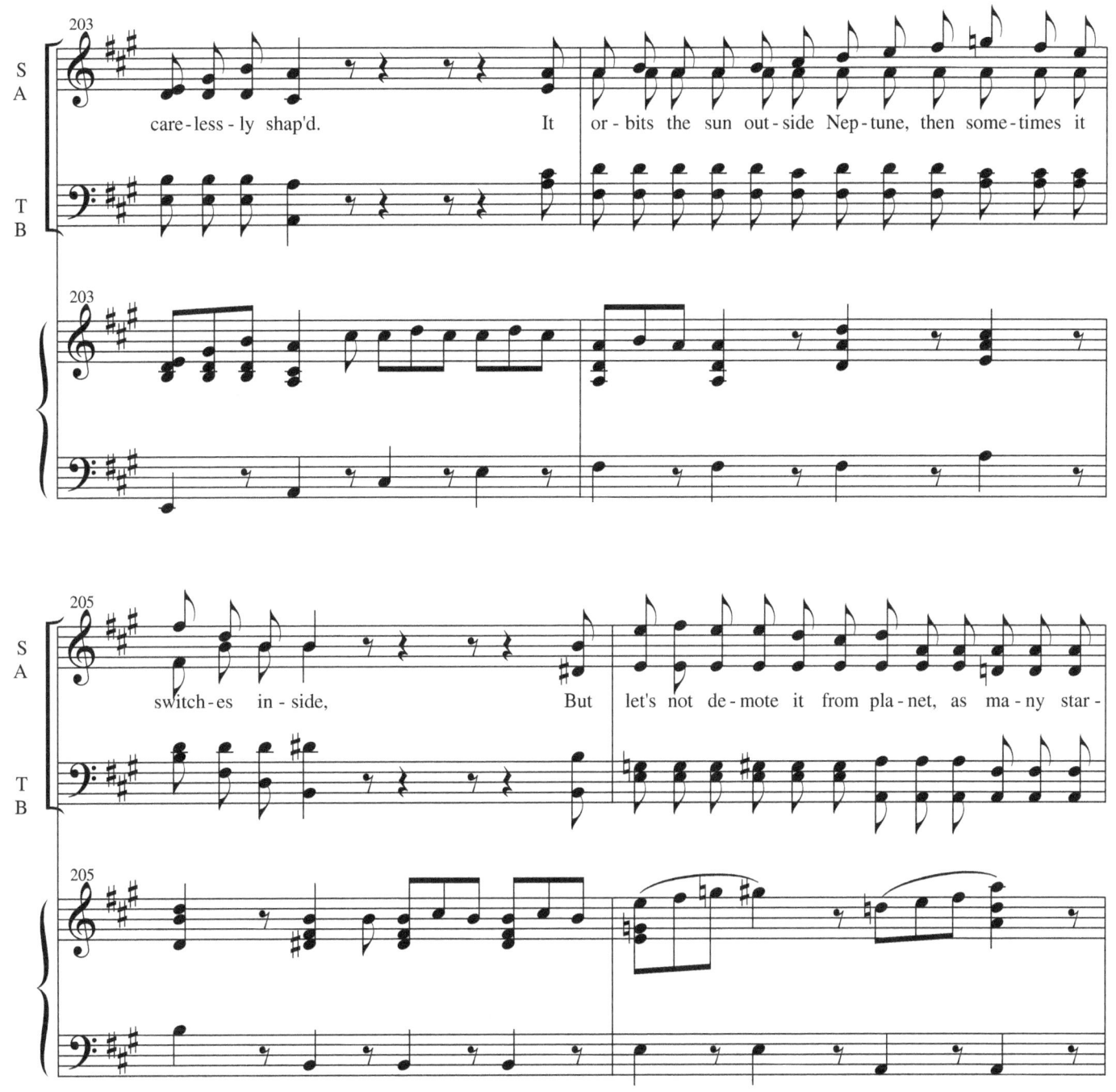

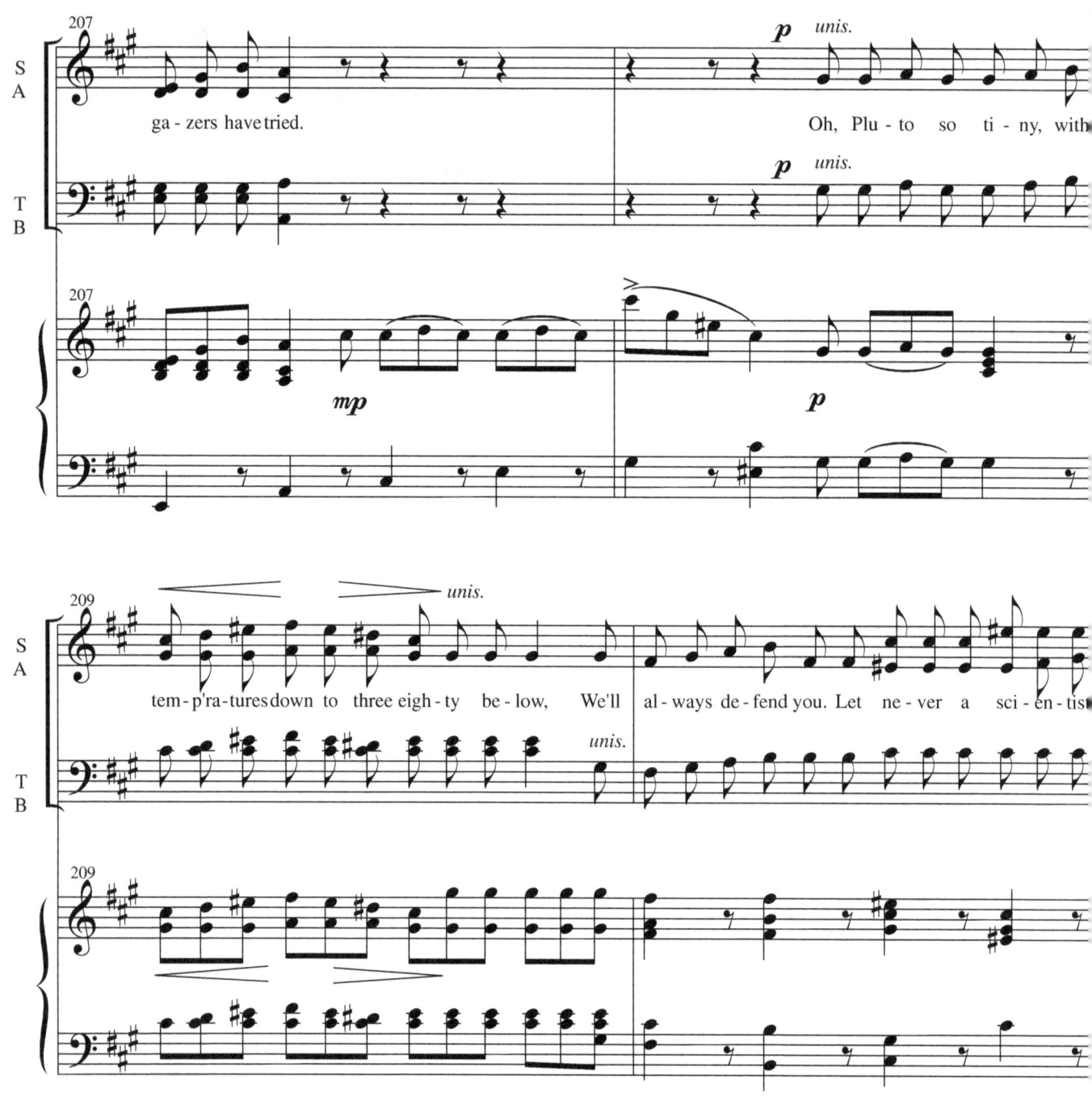

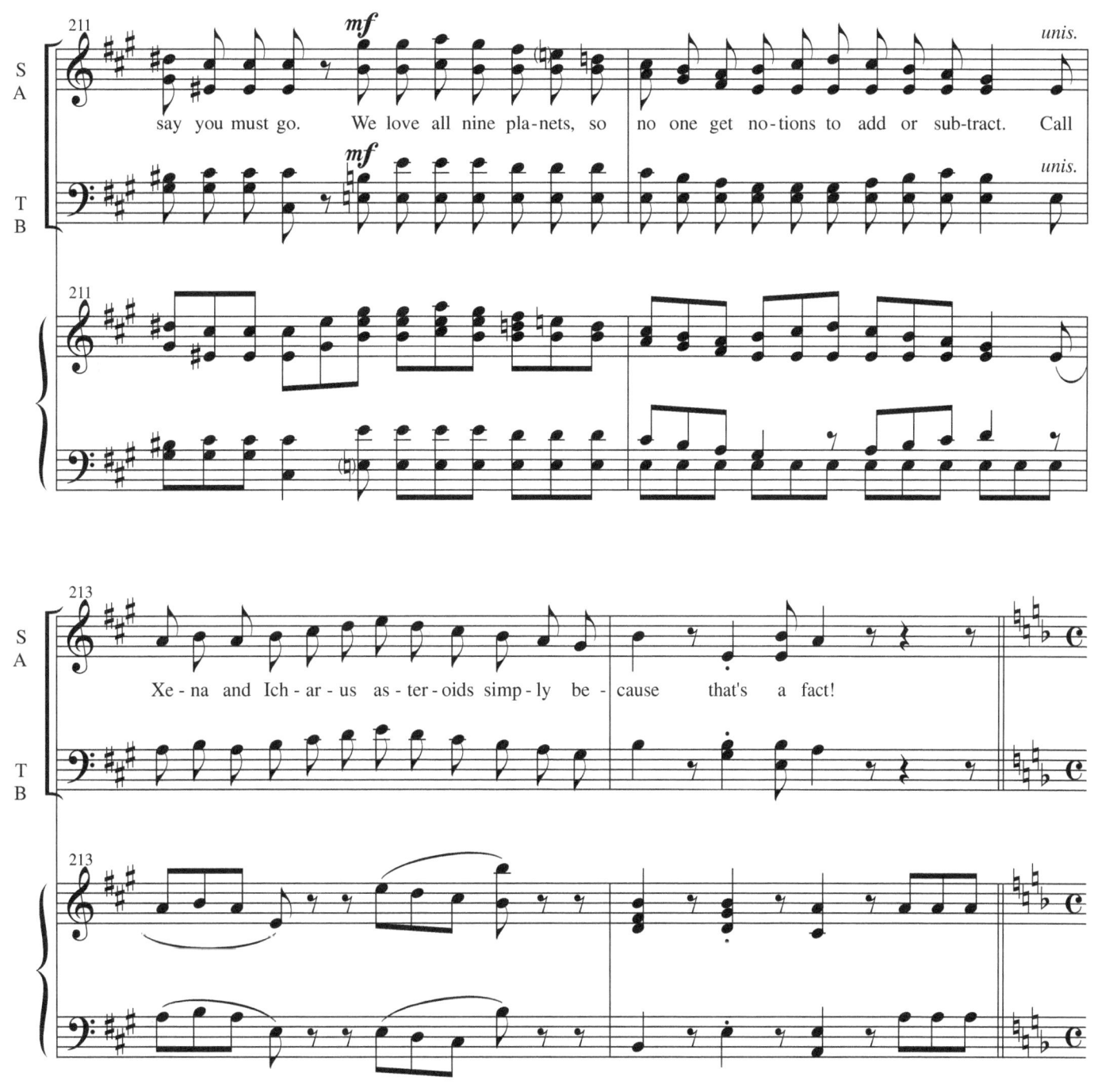

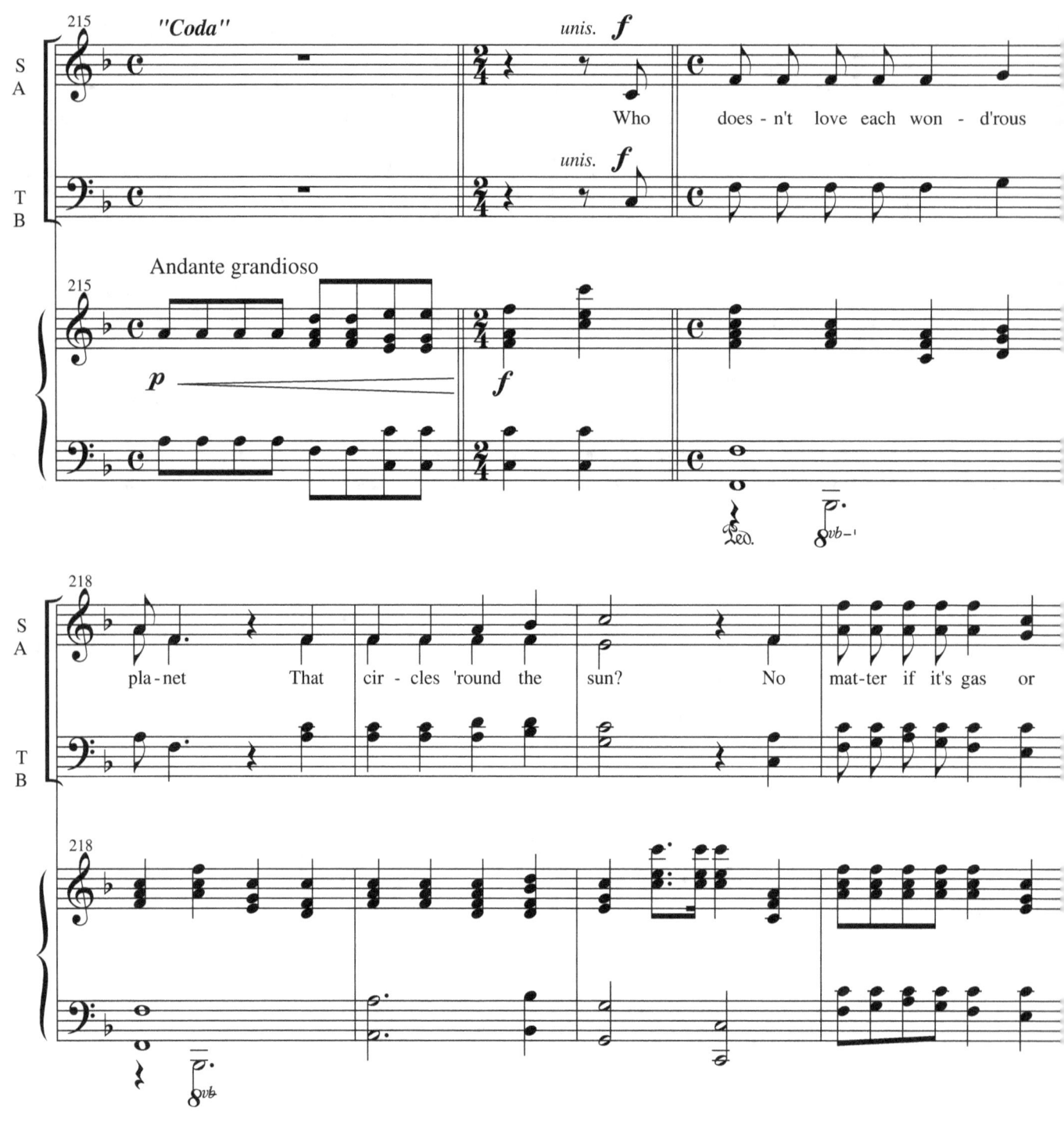

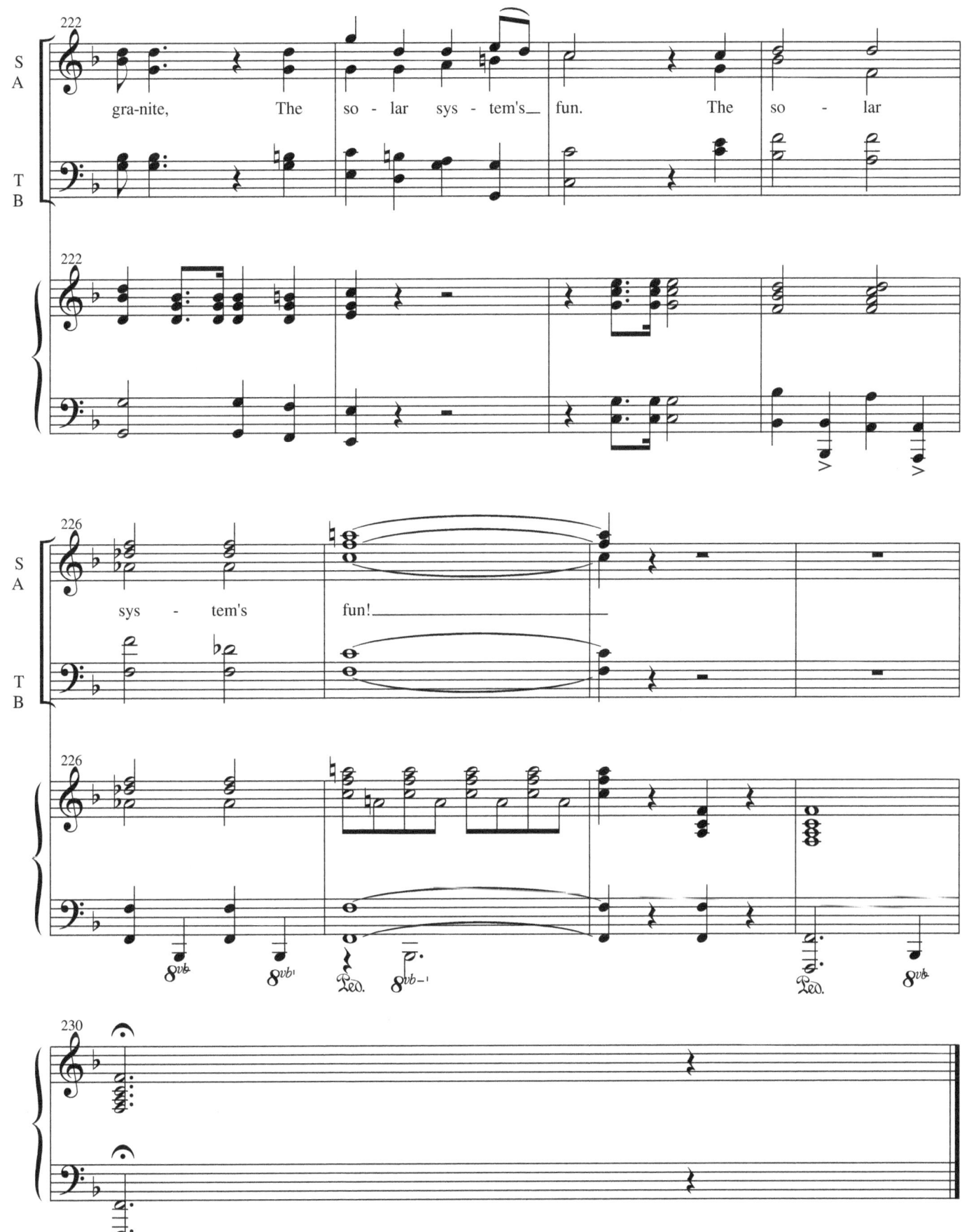

Sonnet 75

Words by Edmund Spenser

Music by Scott F

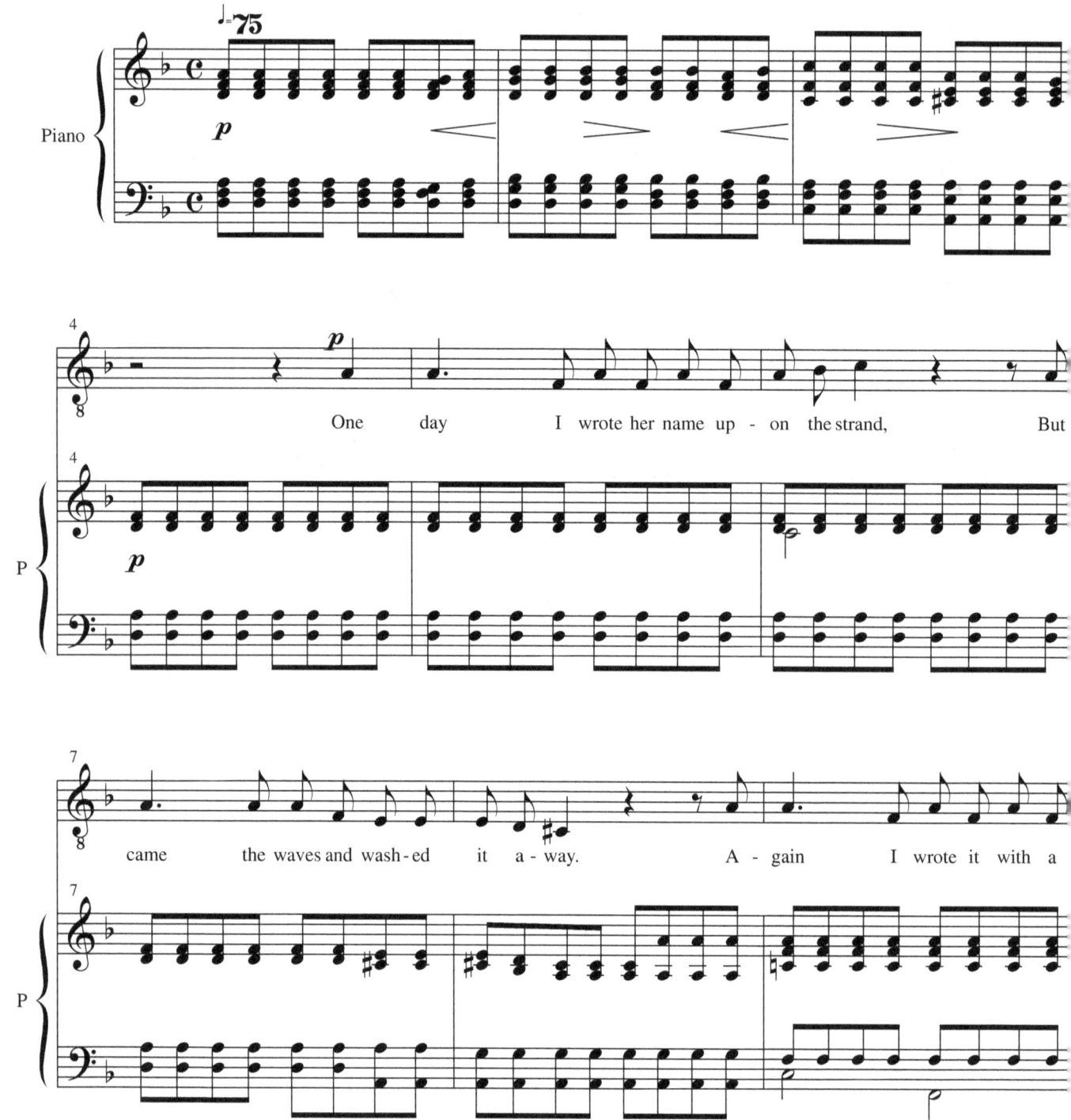

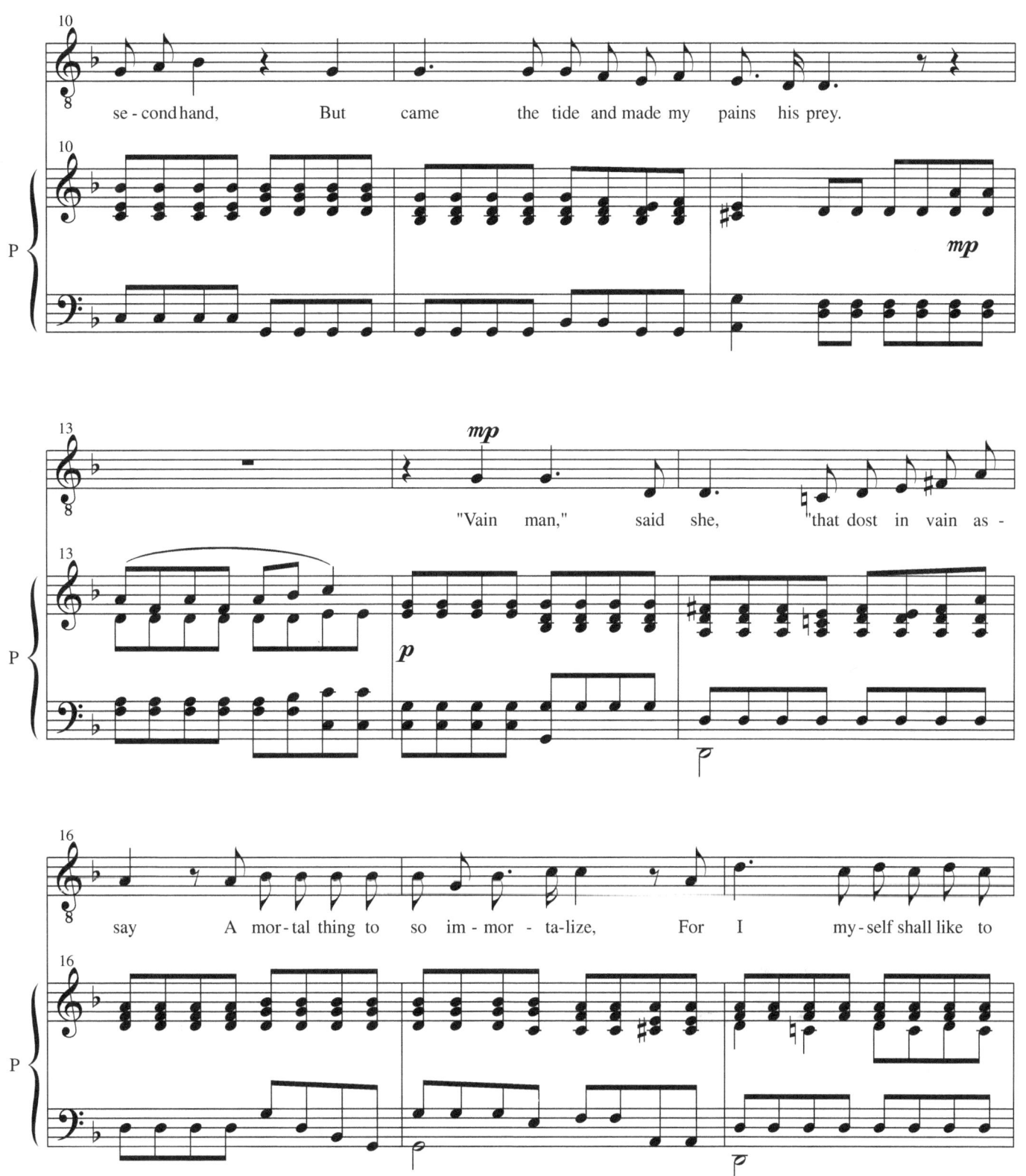

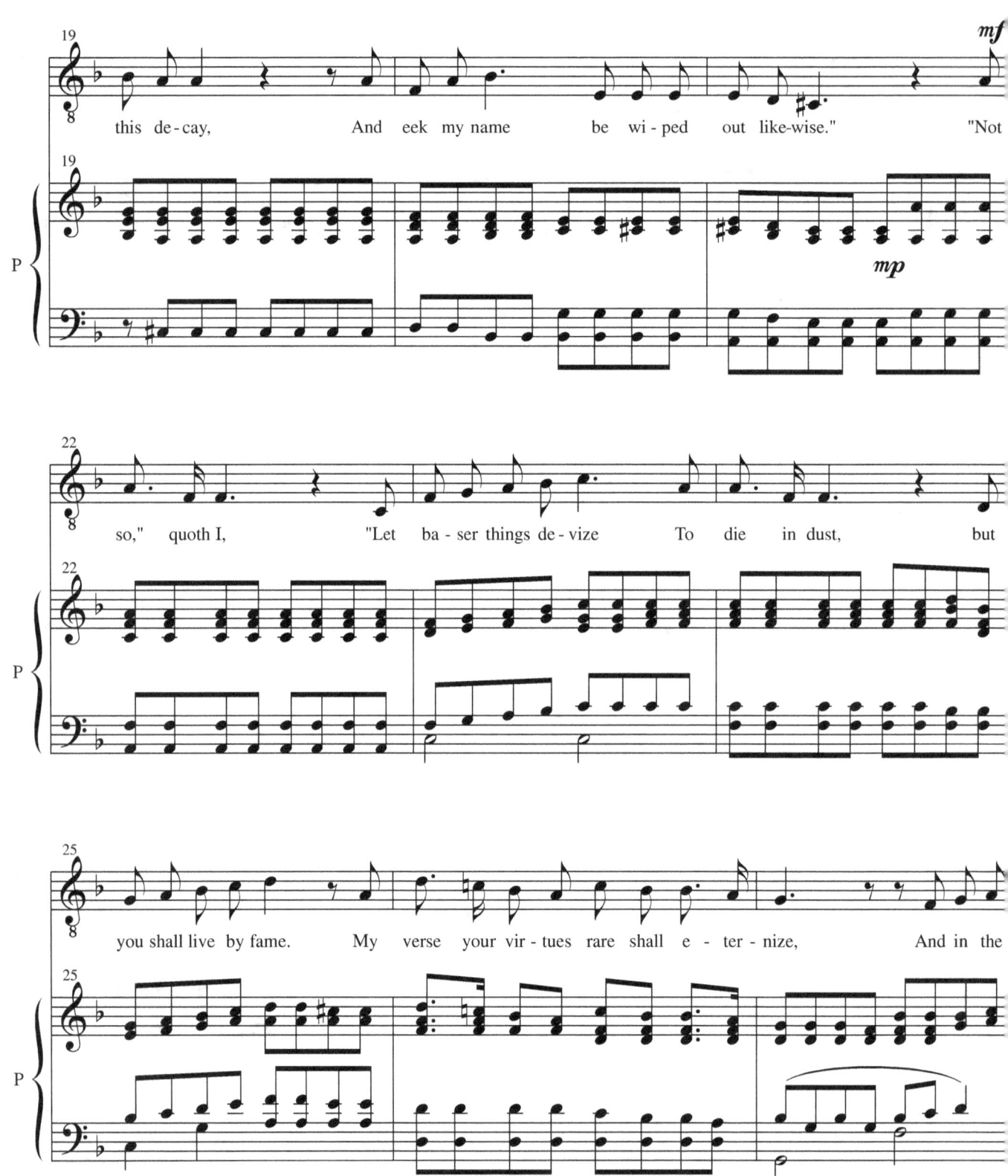

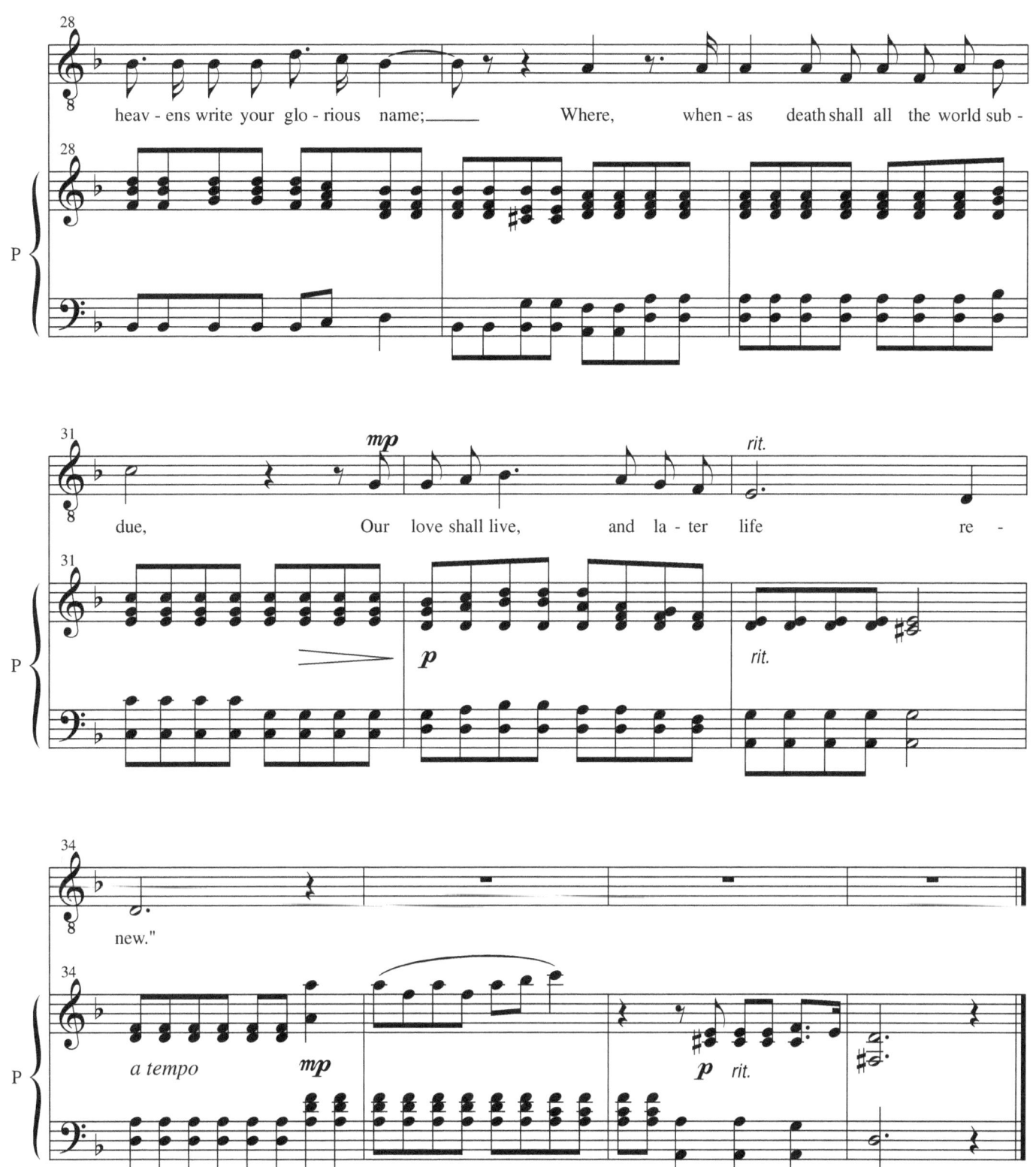

from *Lindarella's List*

Duet - Mabel and Alexander

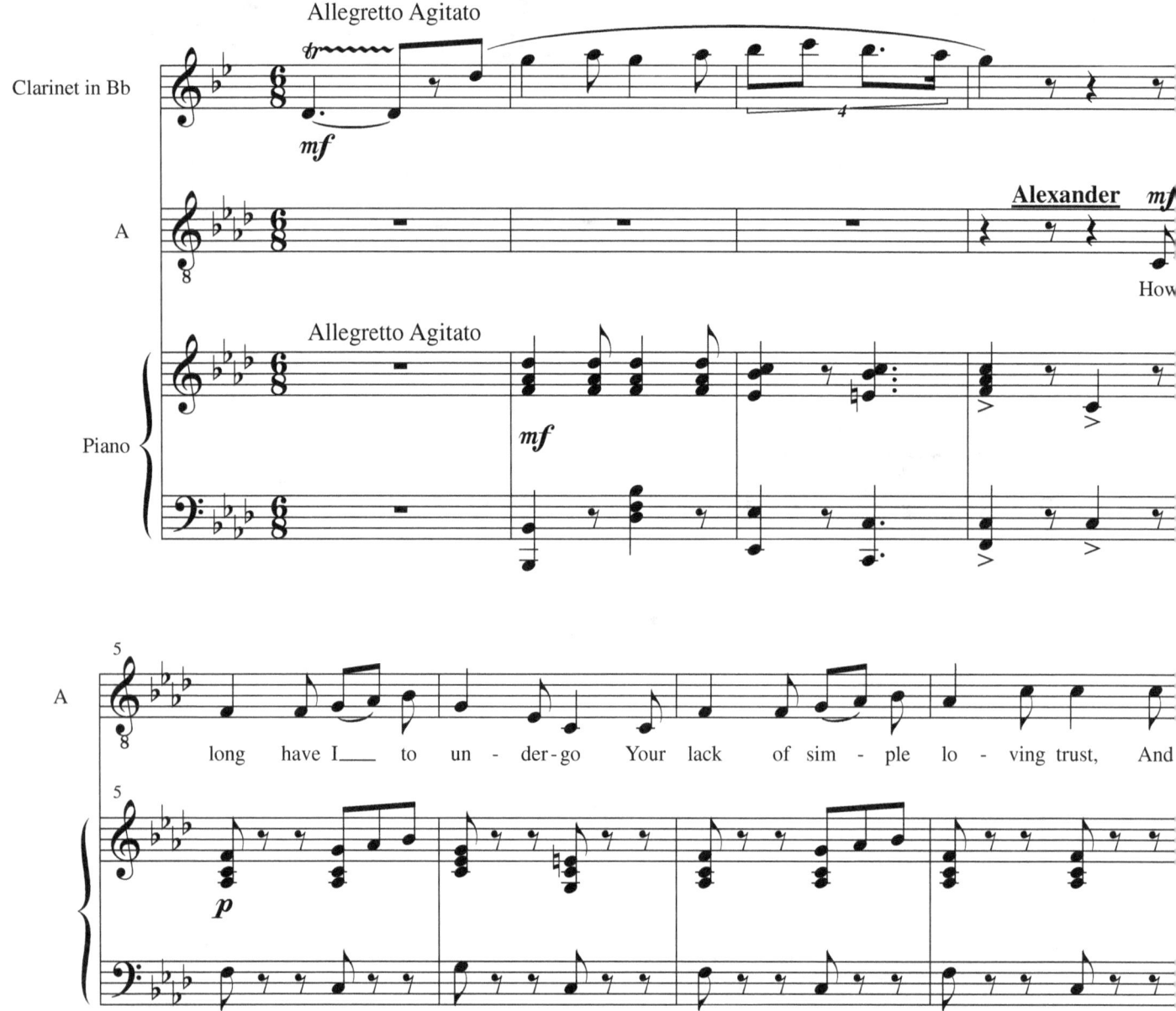

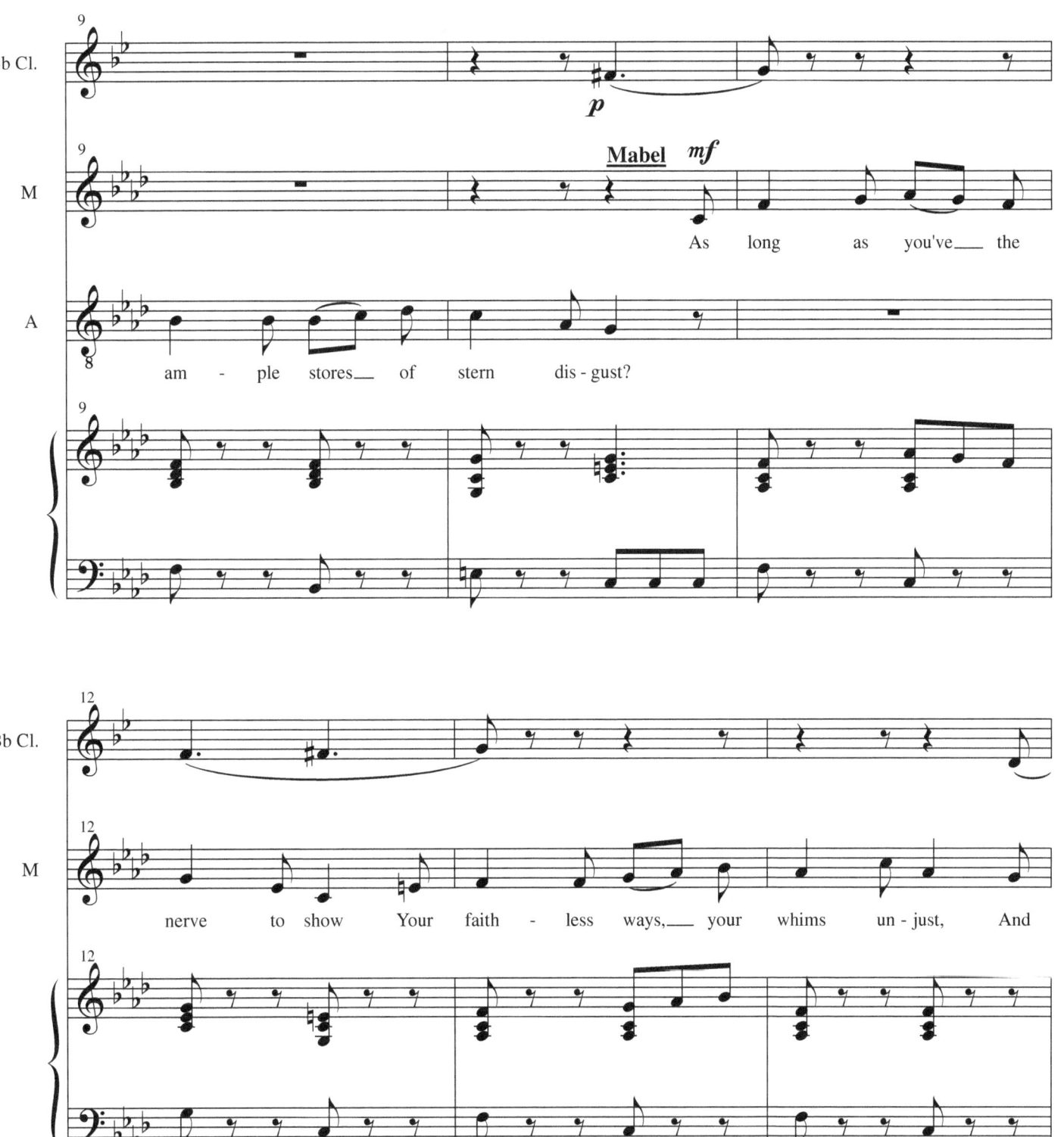

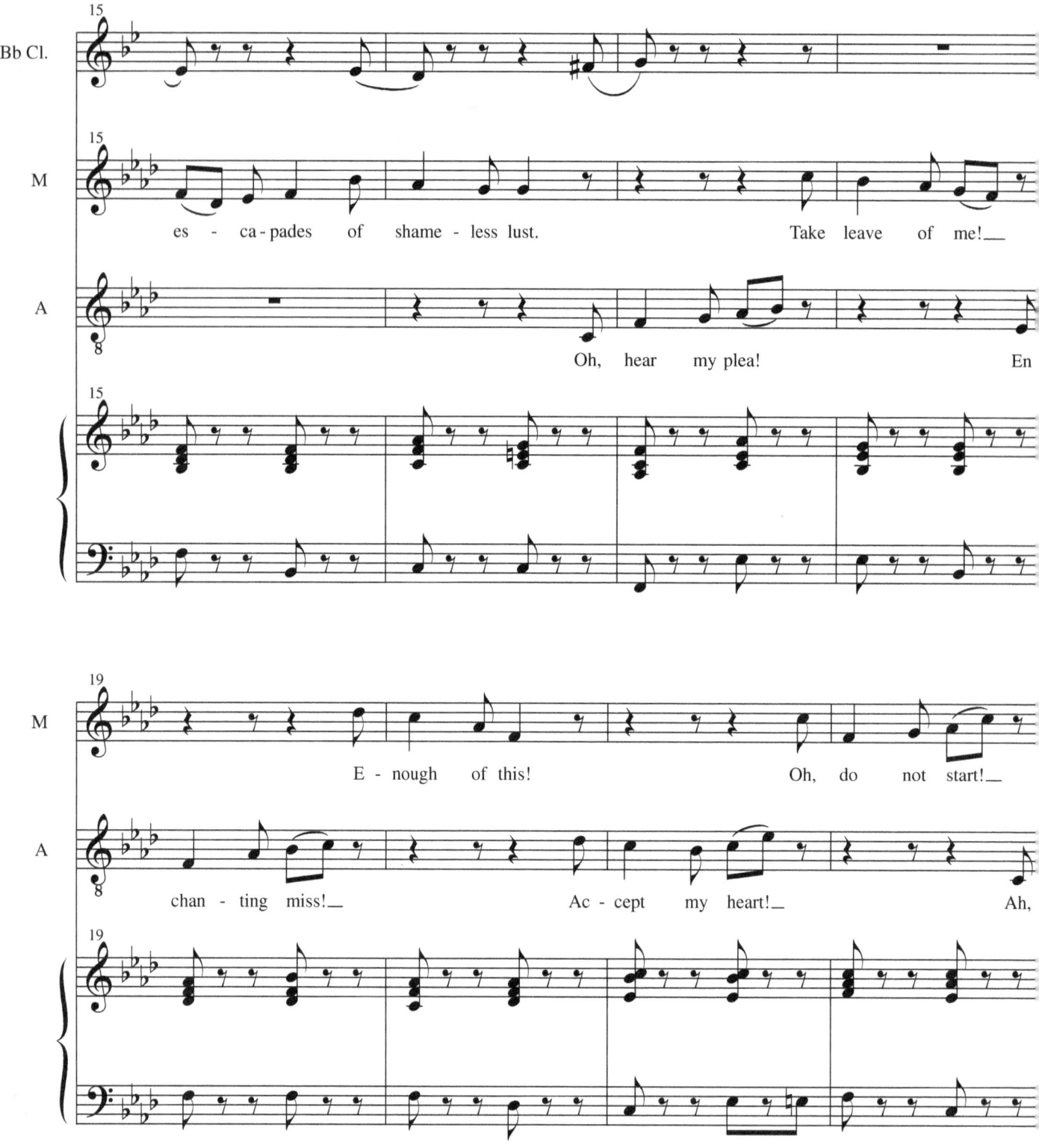

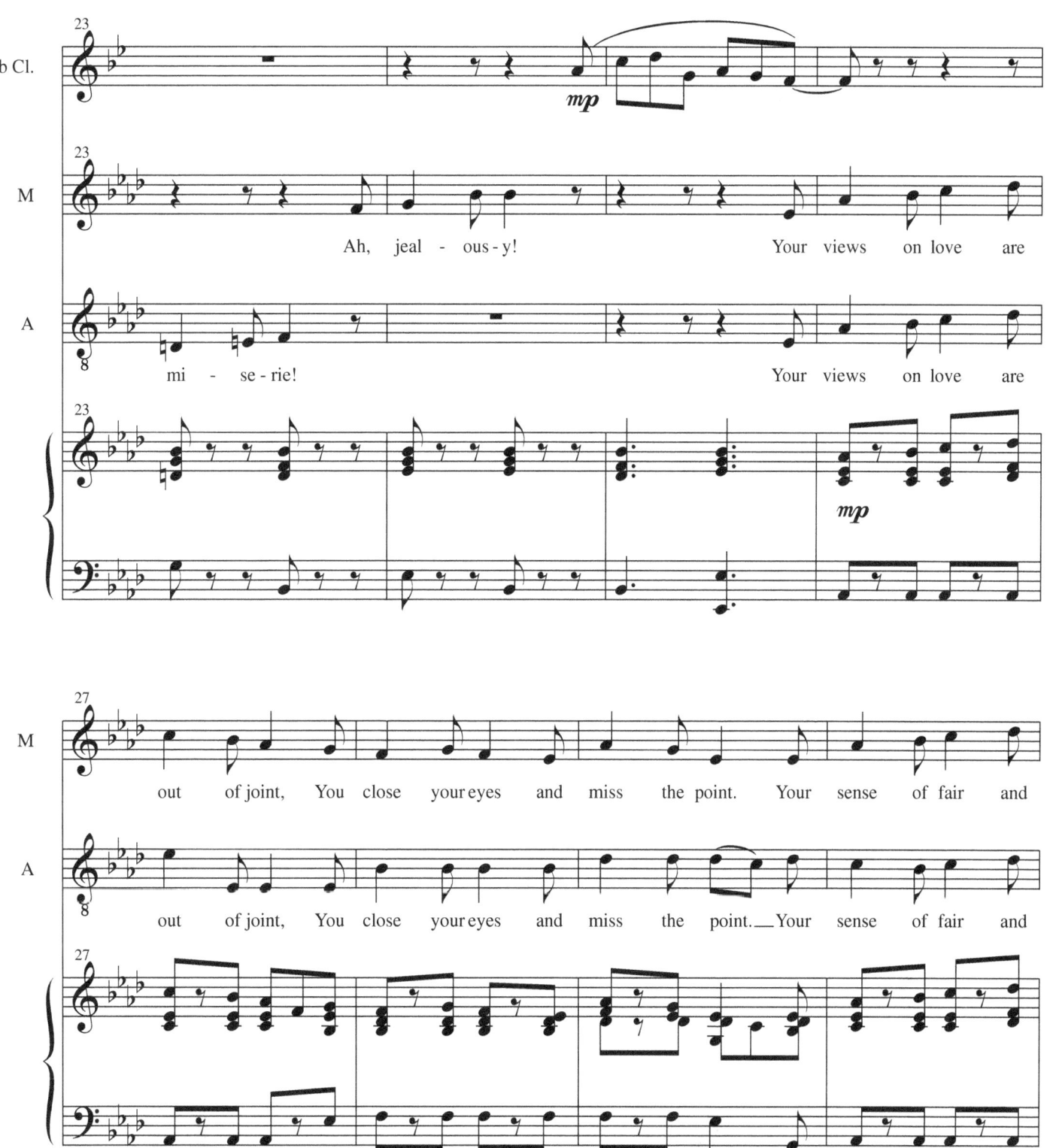

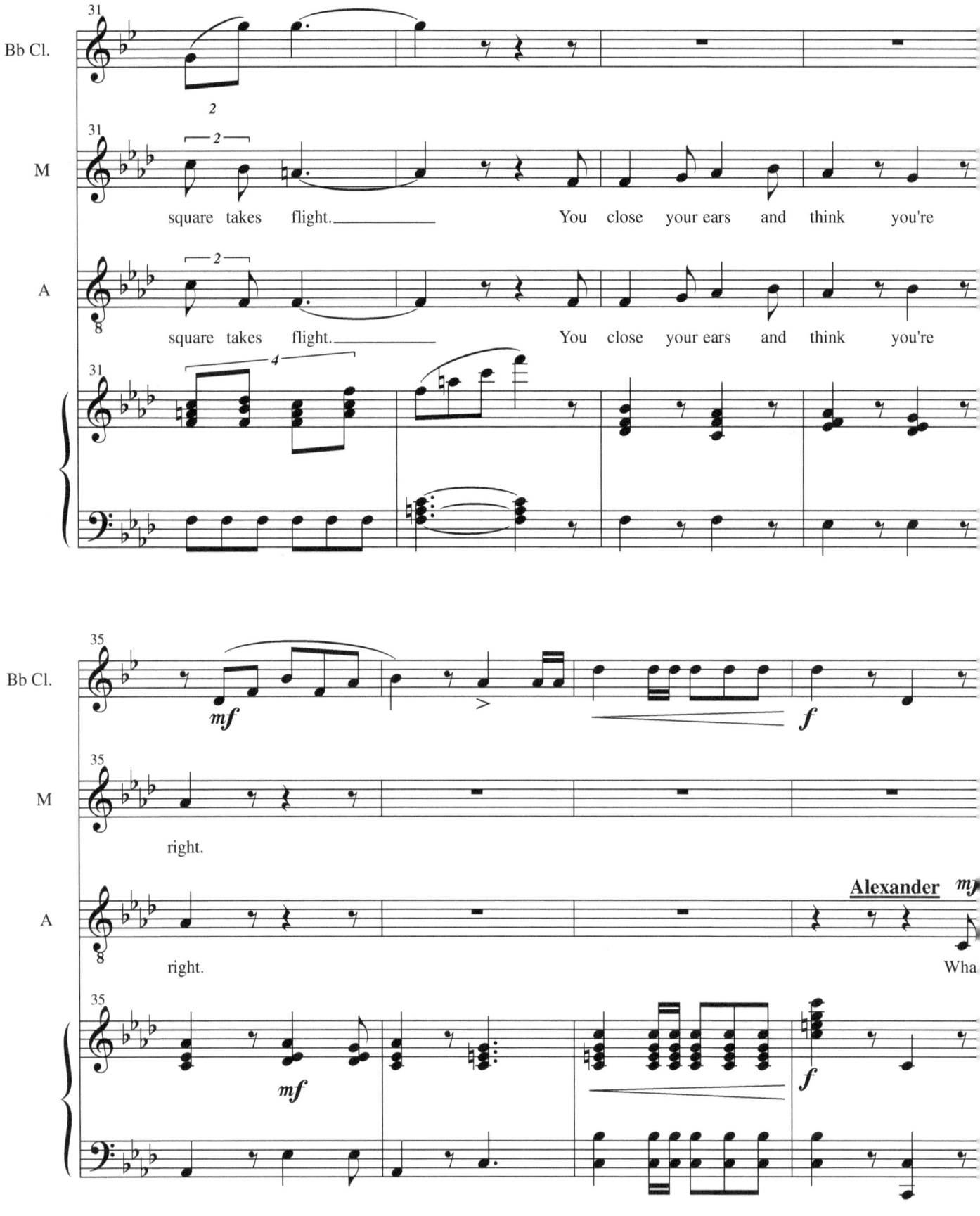

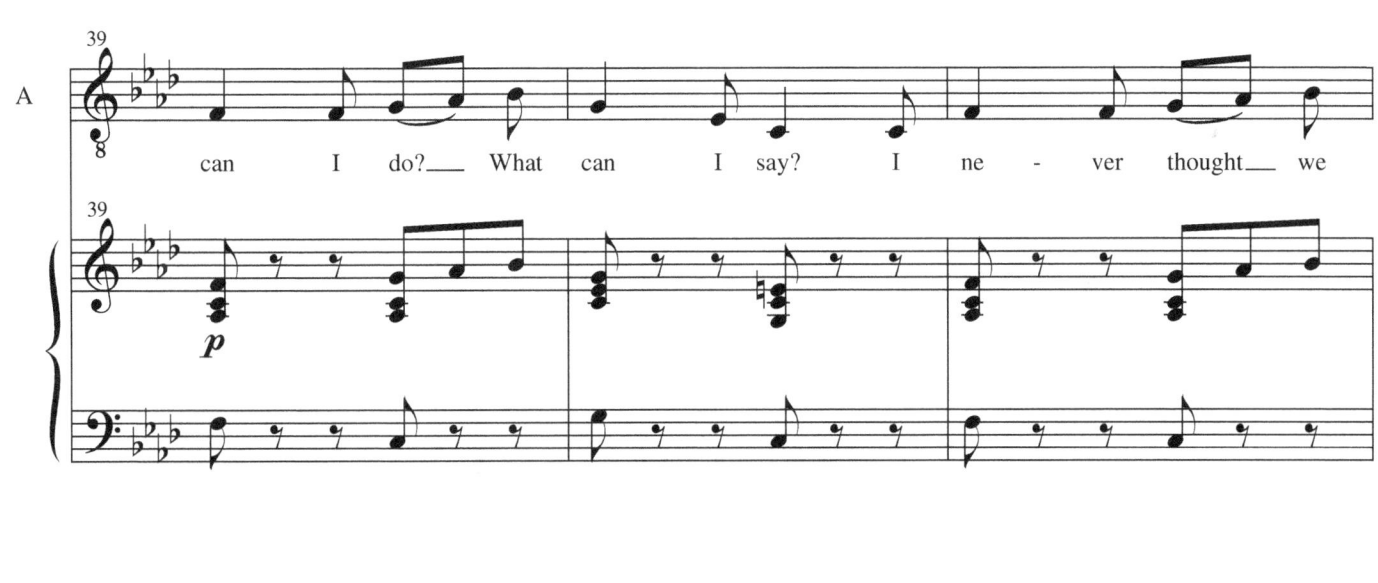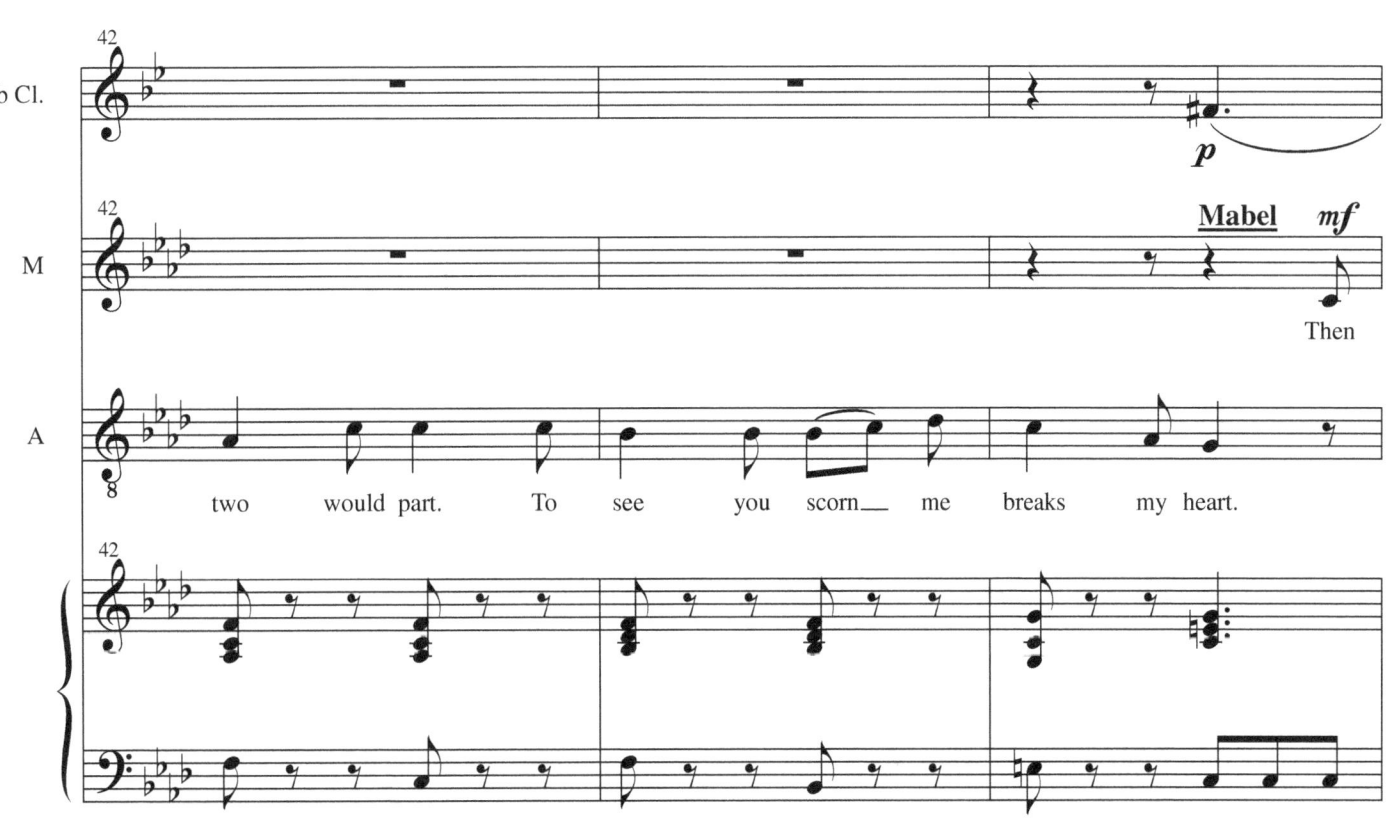

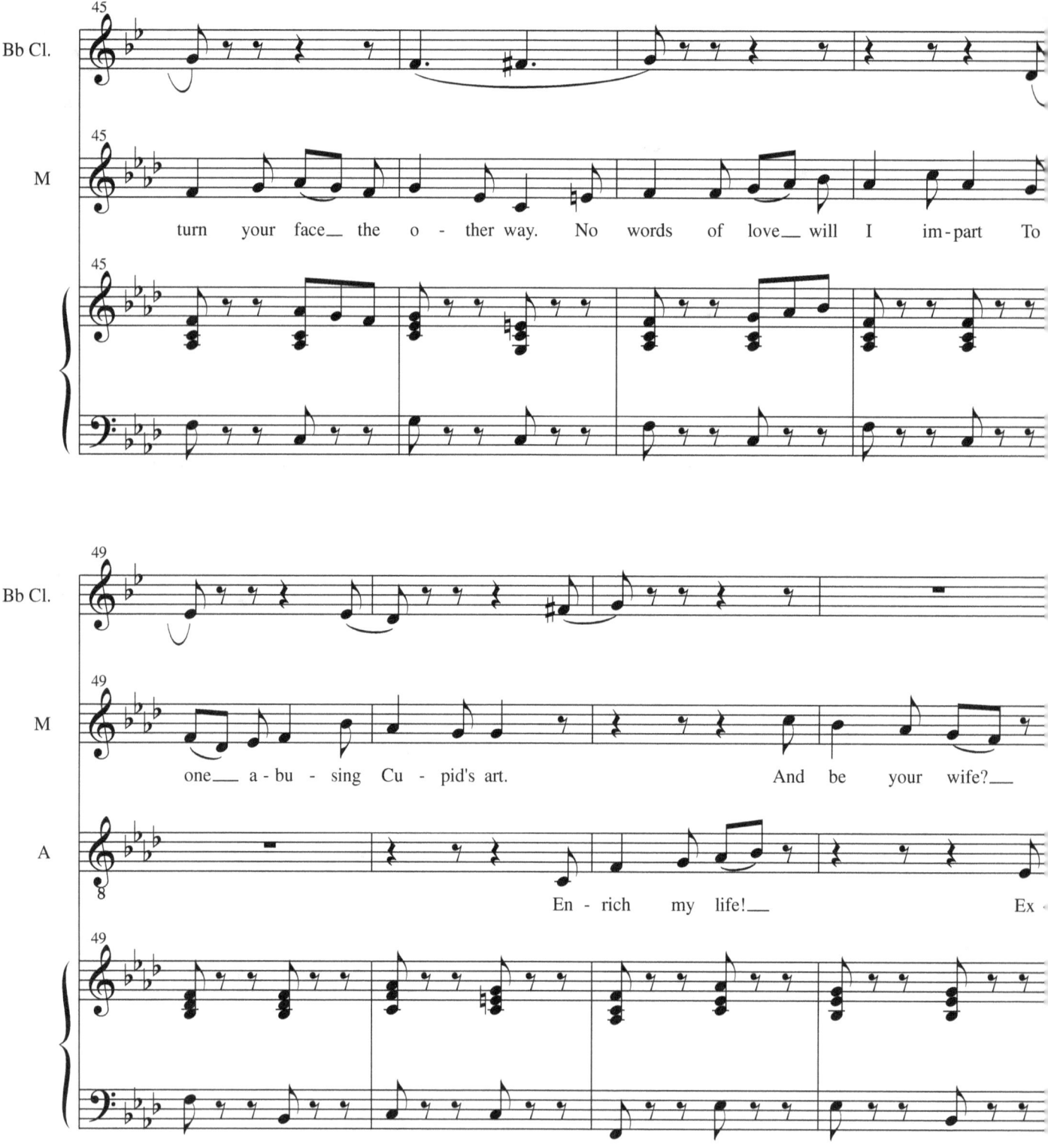

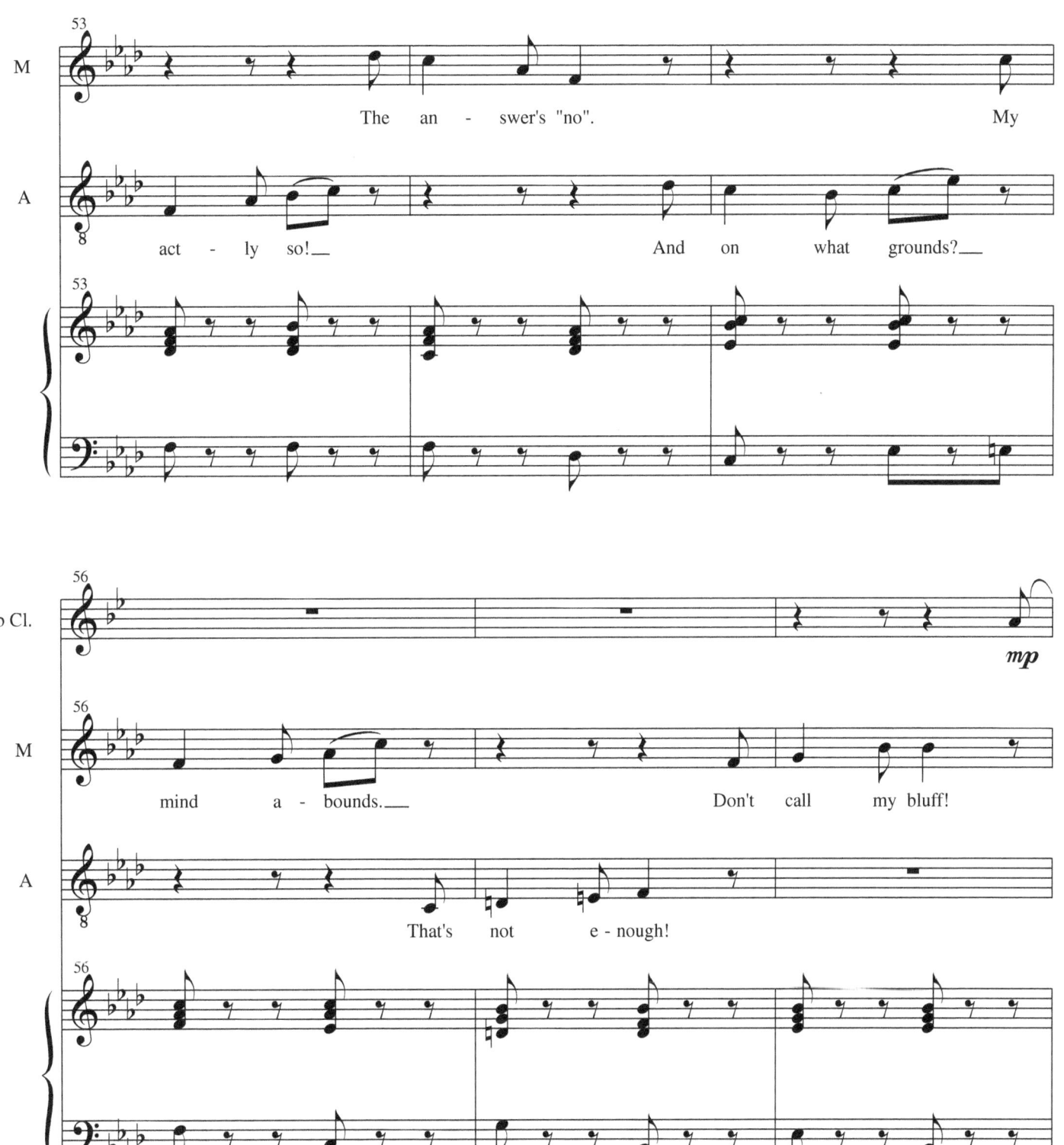

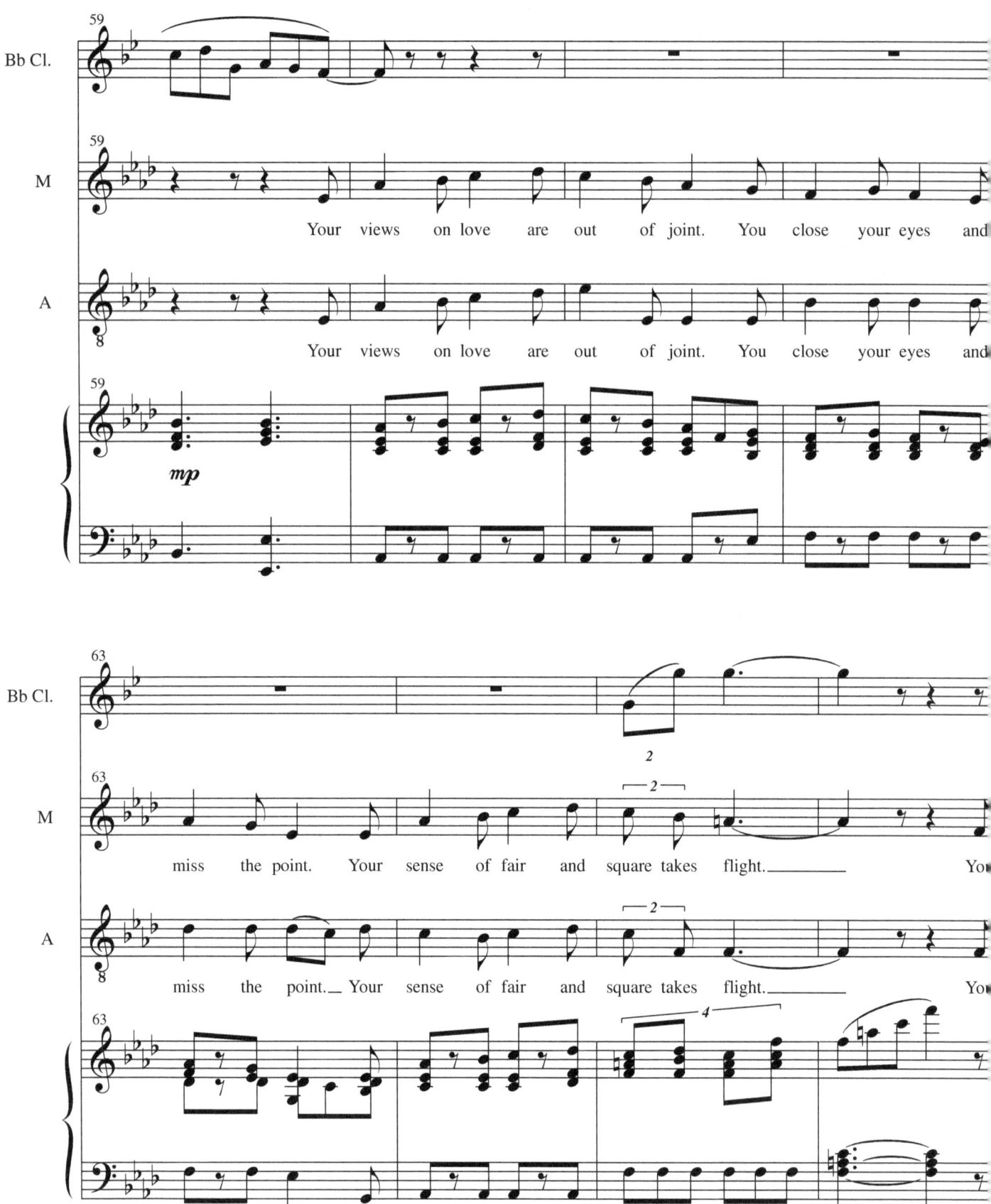

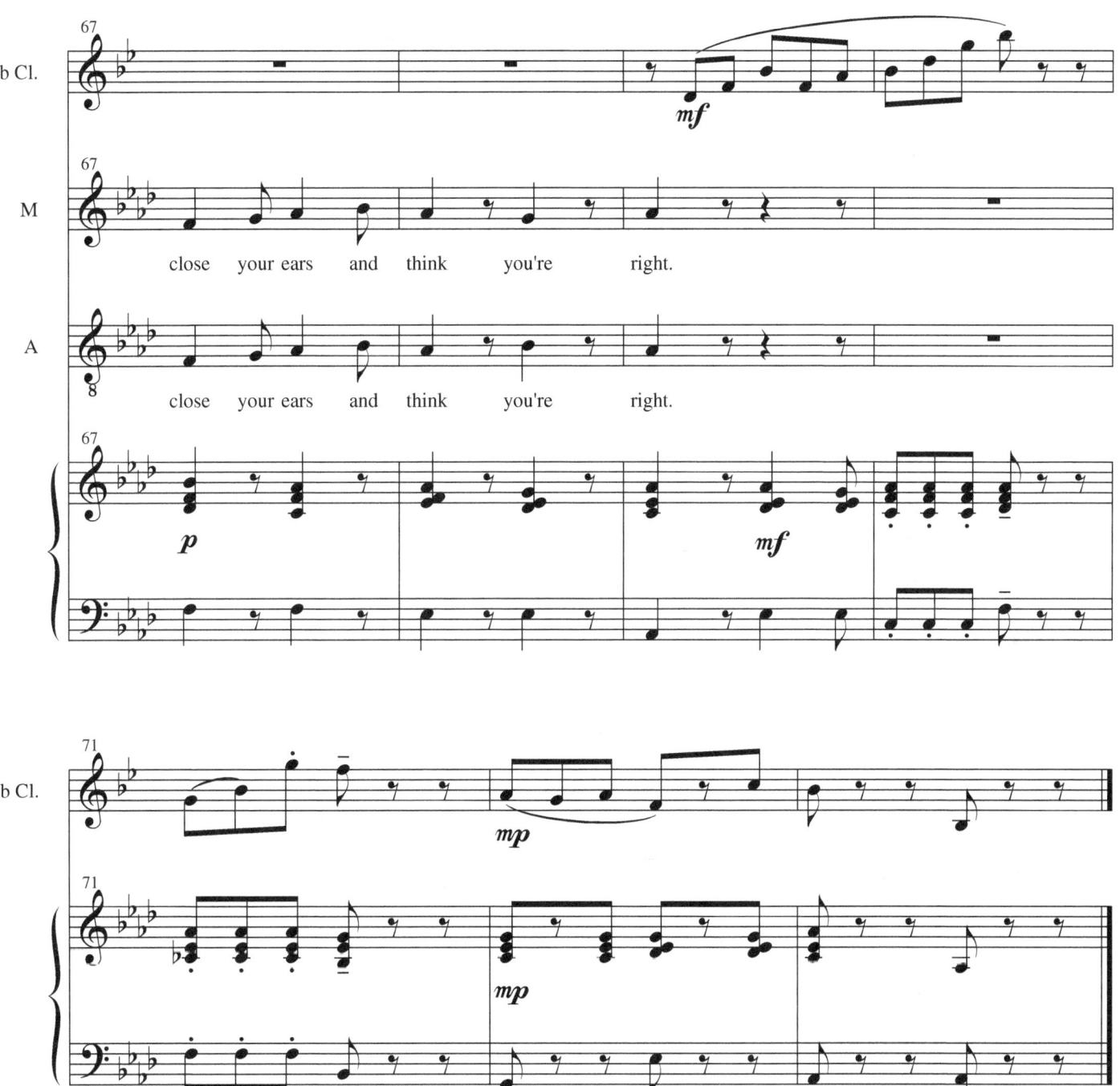

from *Two Merry Monarchs*
Song: "Music and mirth" (Chorus)

Solo: "Since the world began" (Iris and Chorus)

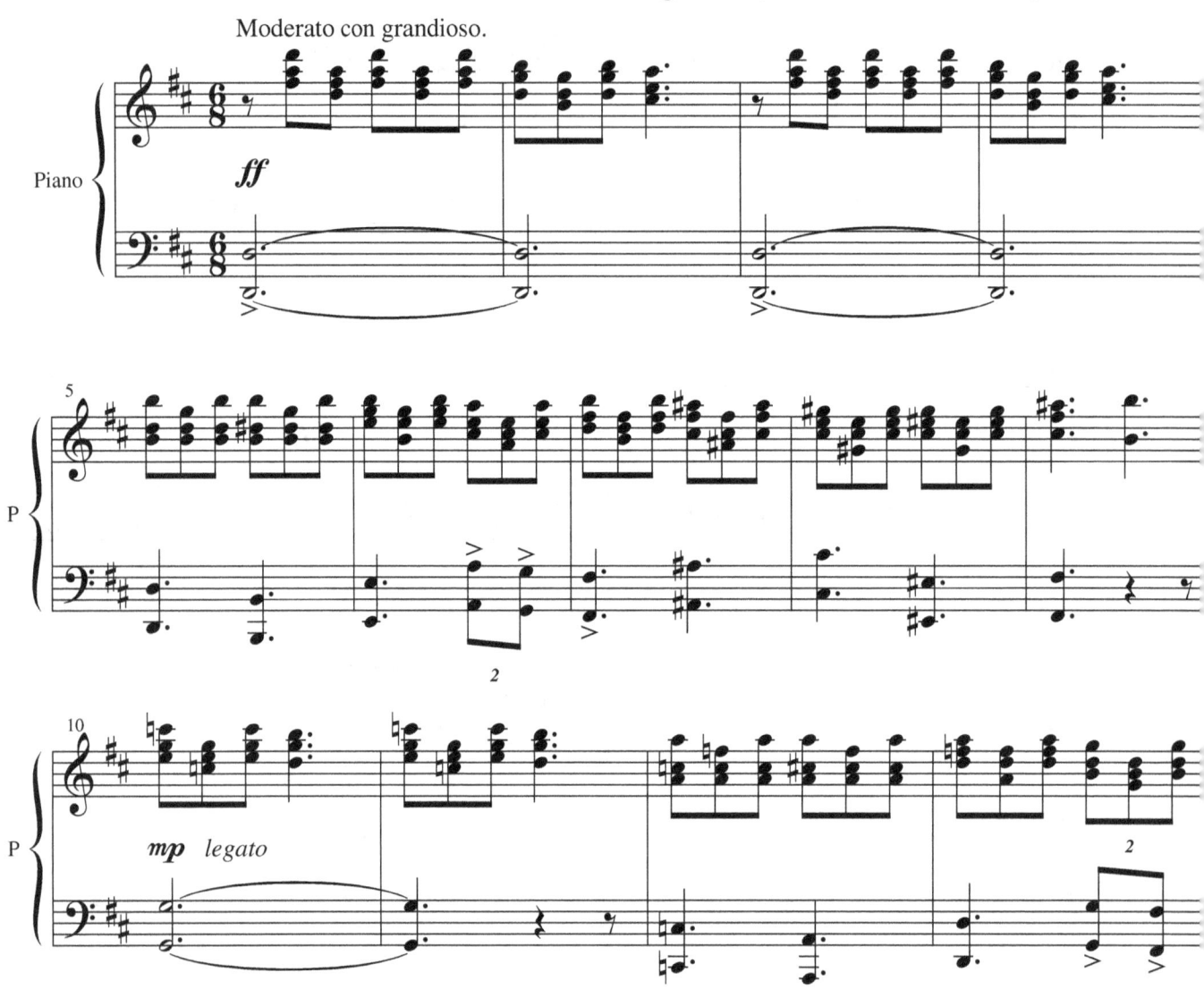

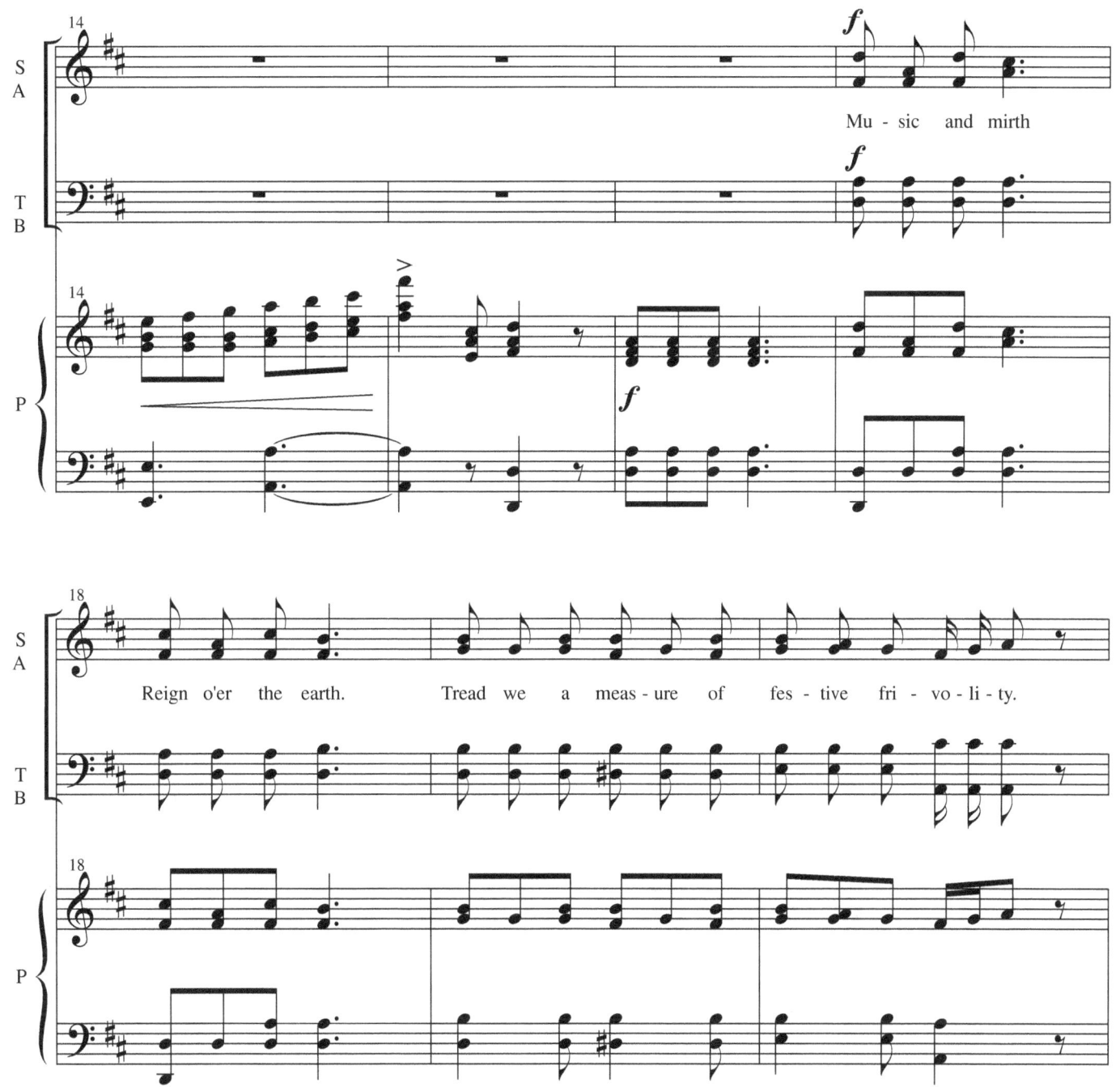

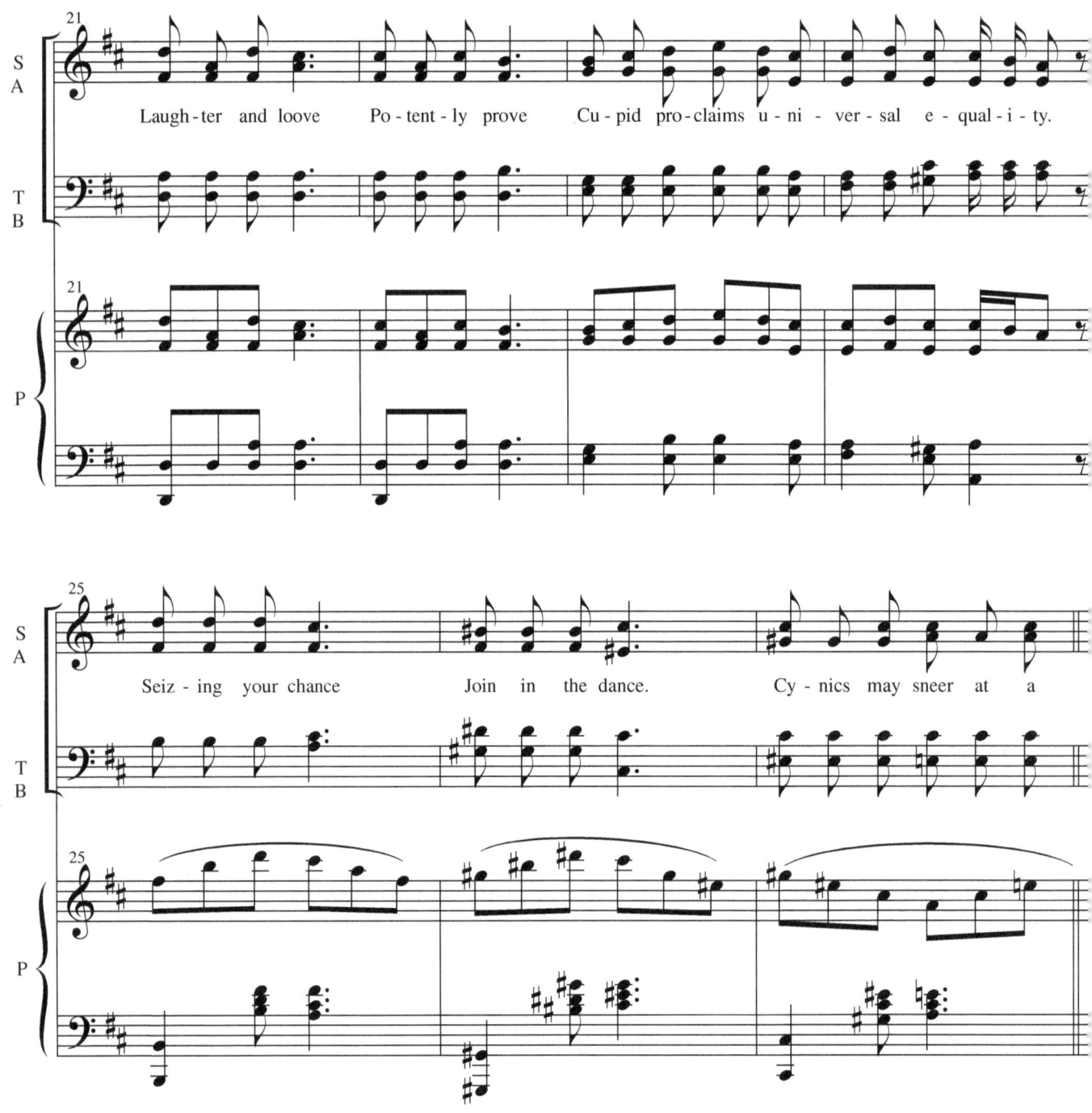

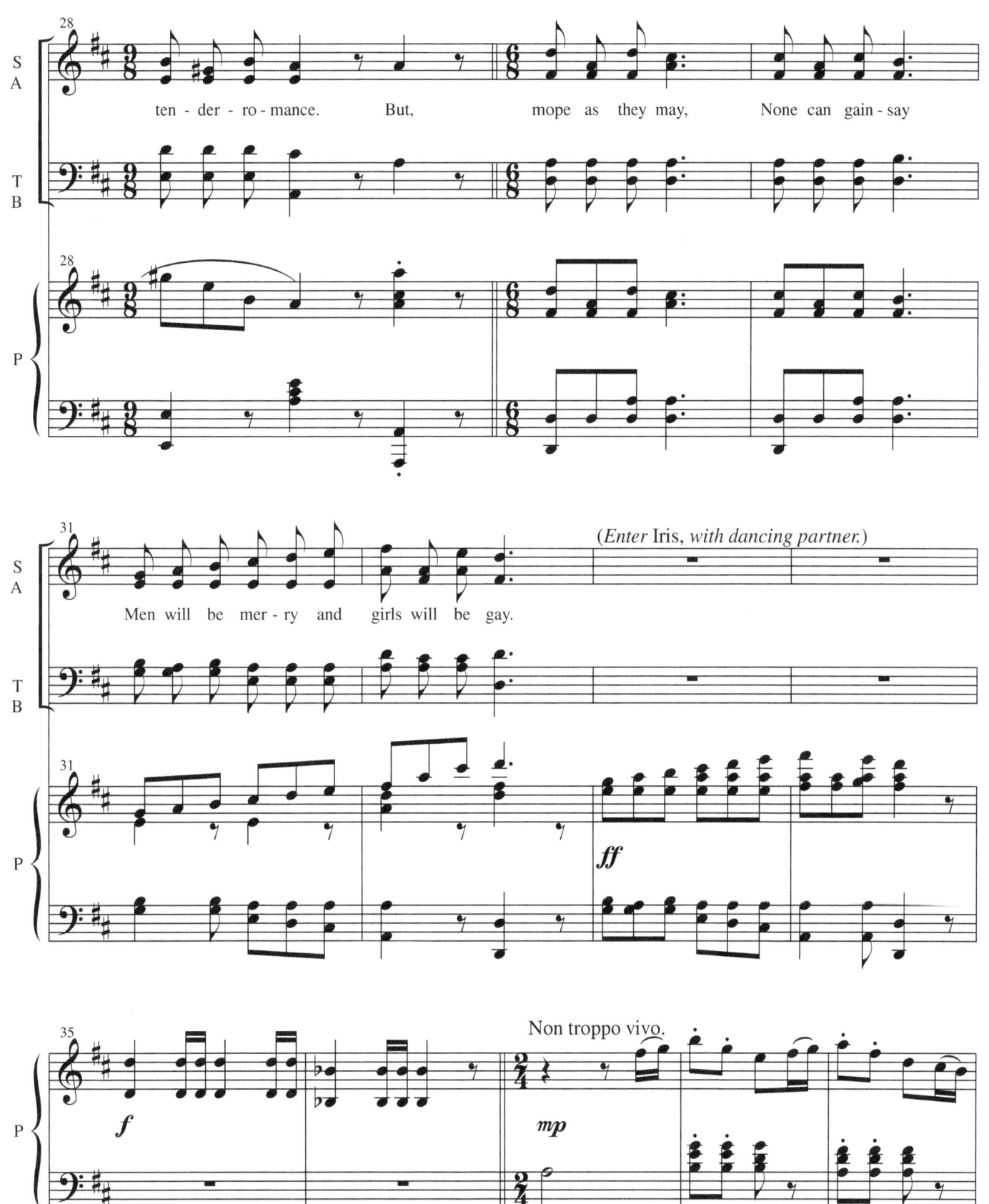

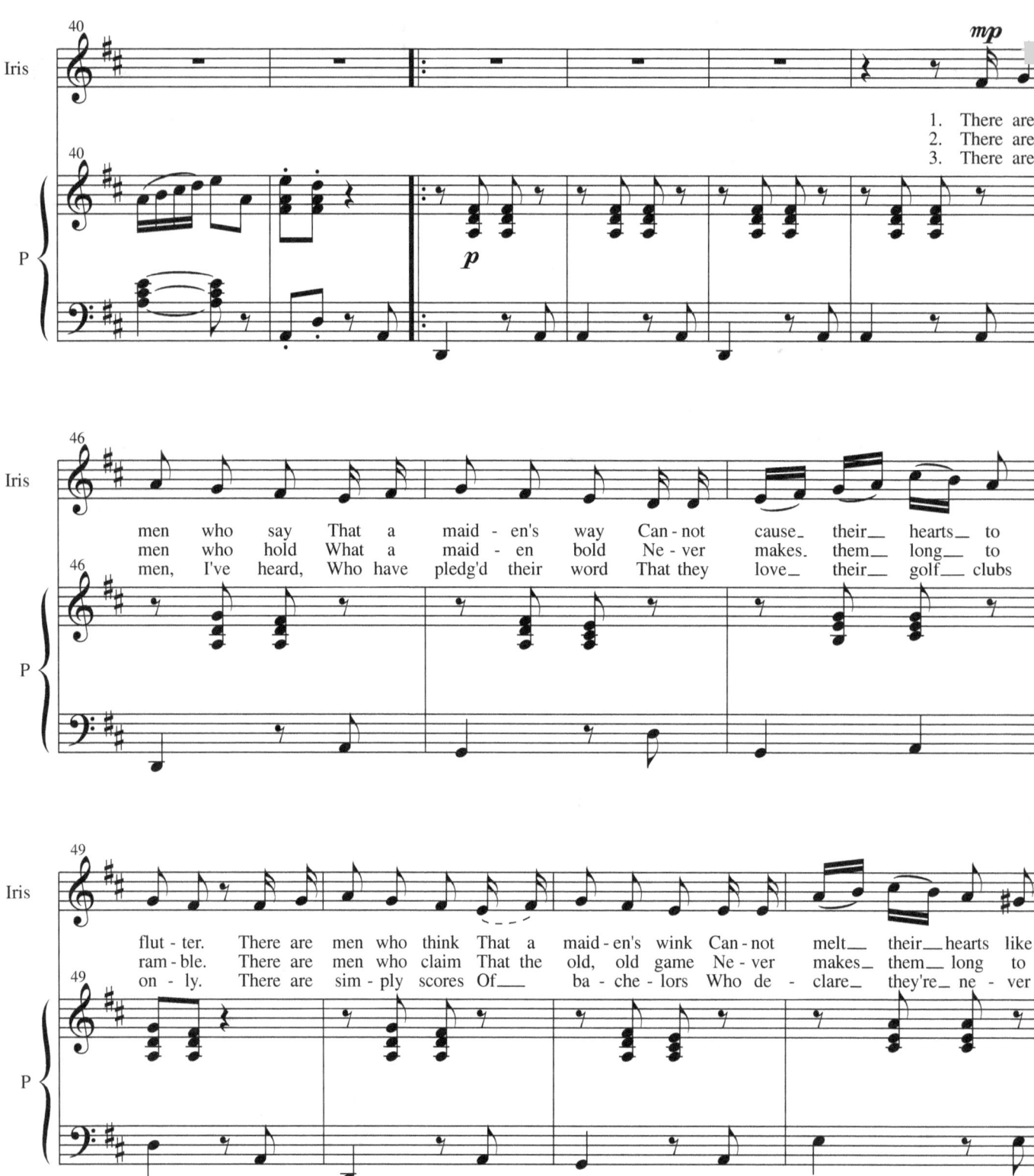

- 49 -

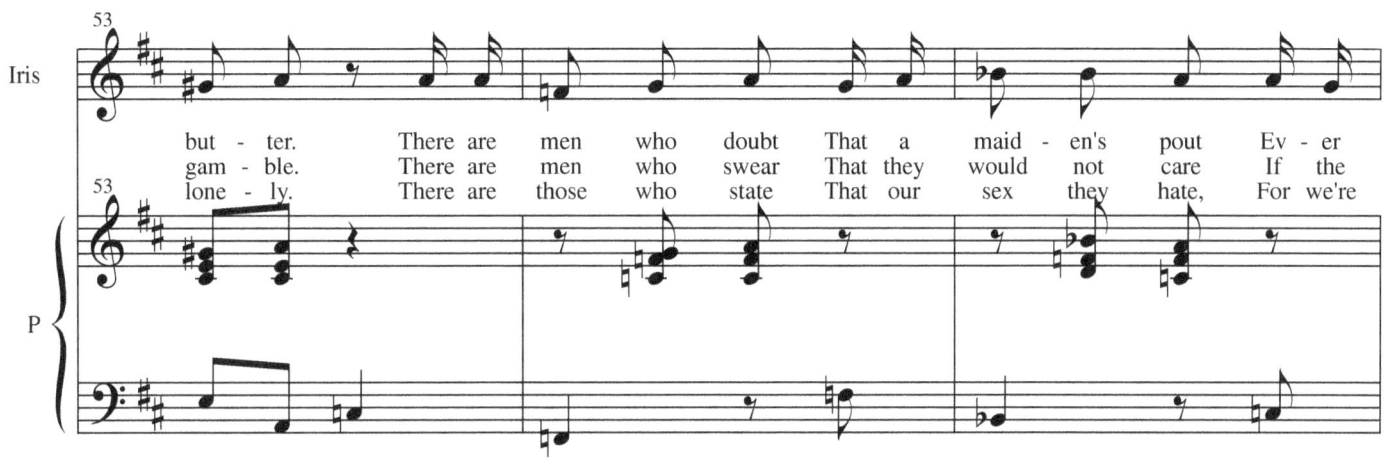
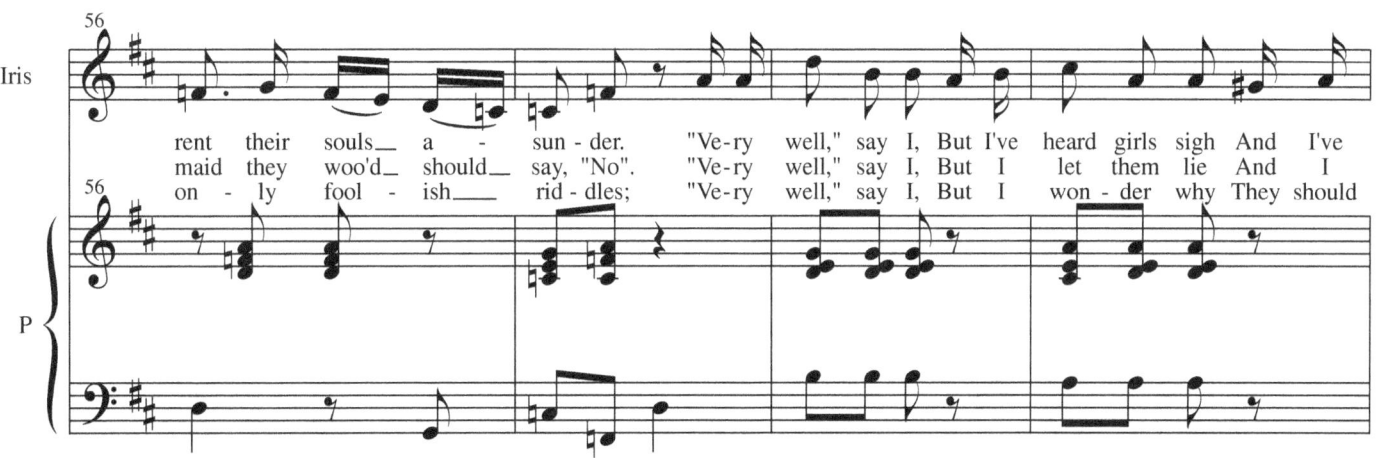
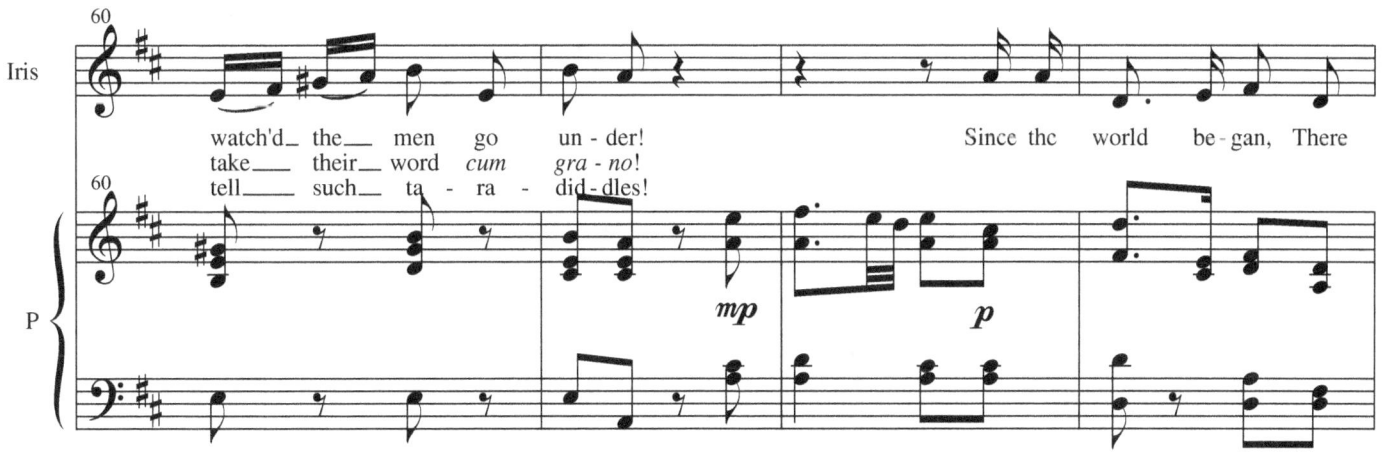

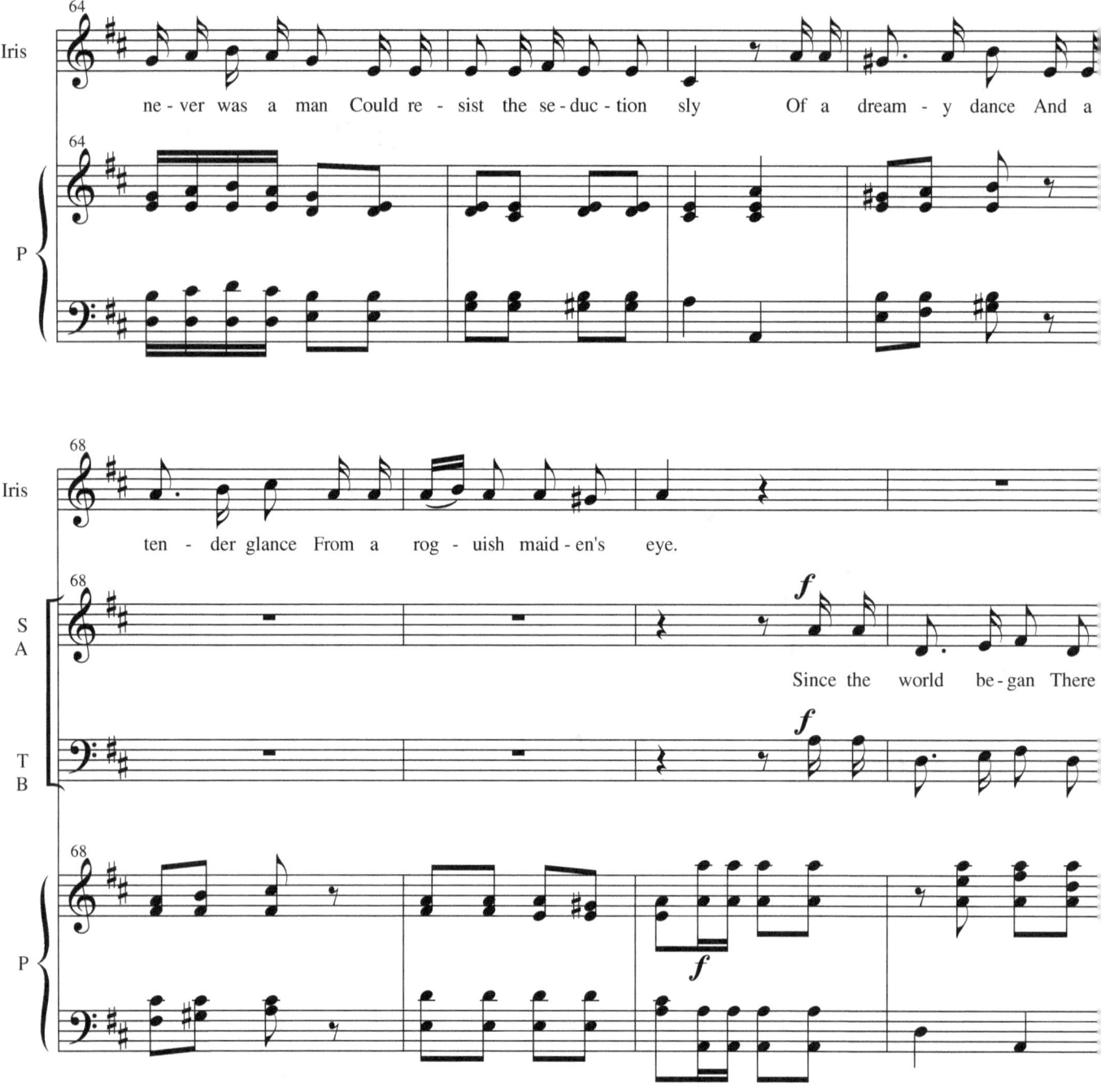

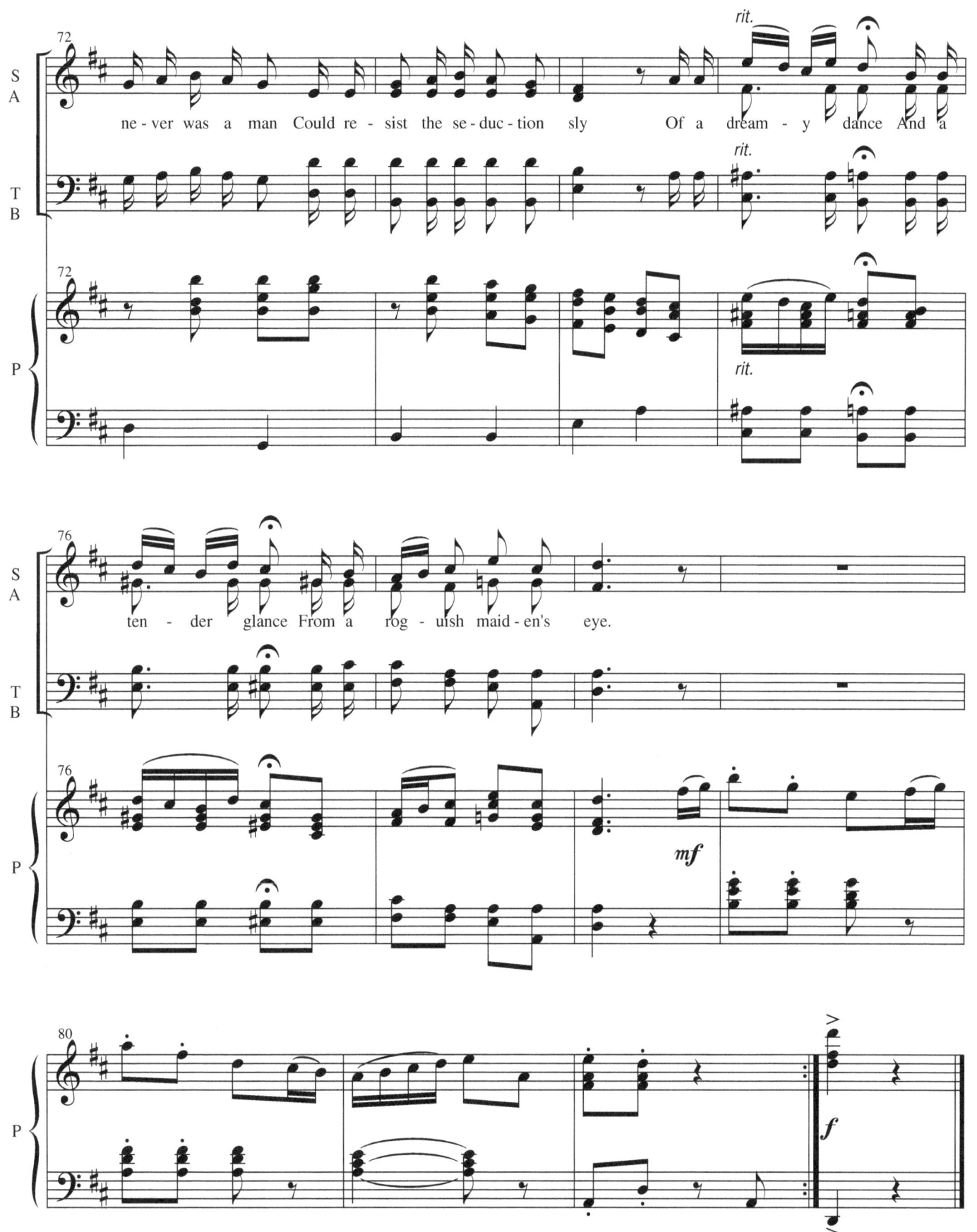

from *Popocateptyl*

No. 2 -- Song (Cuthburt) and Chorus

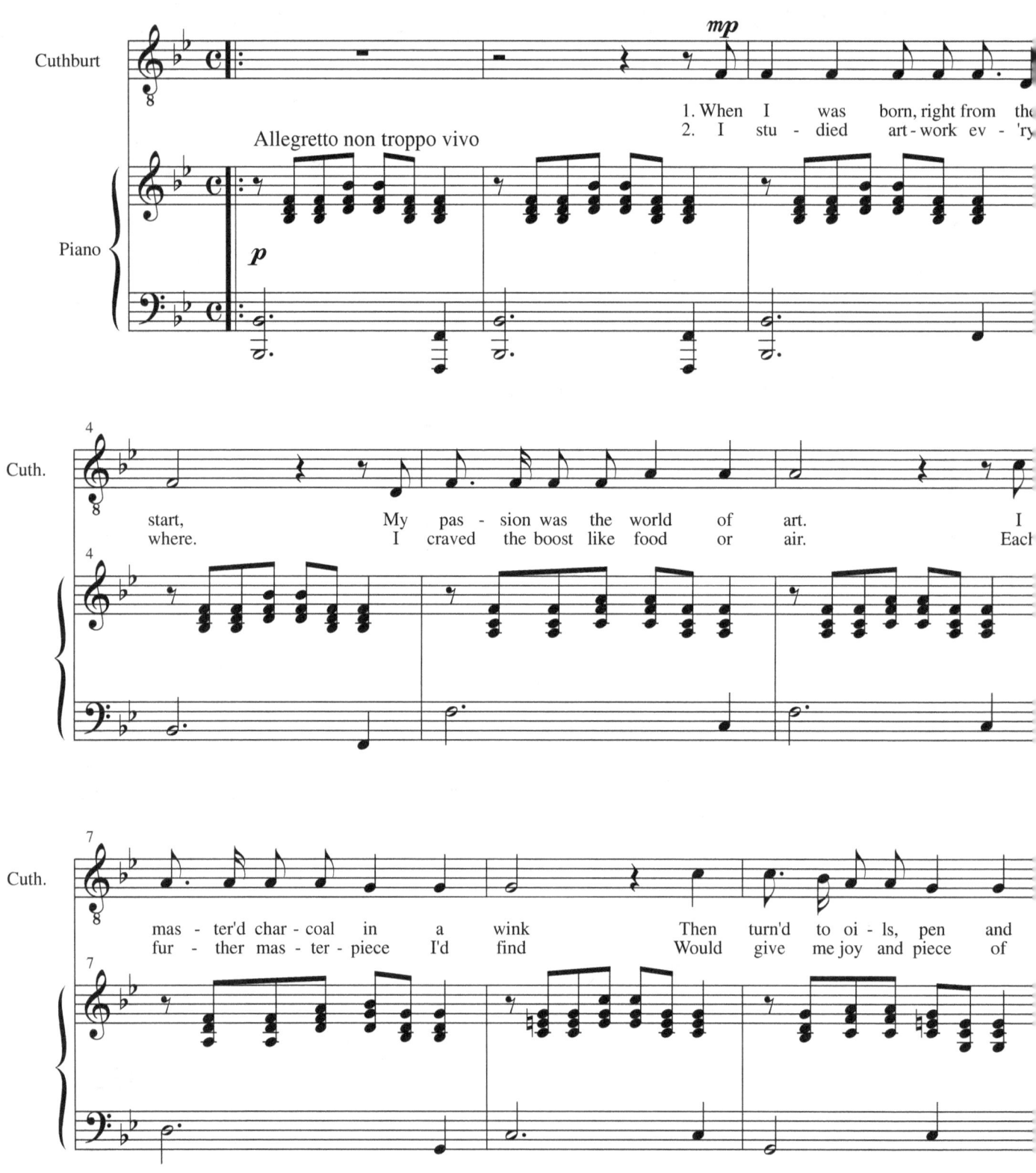

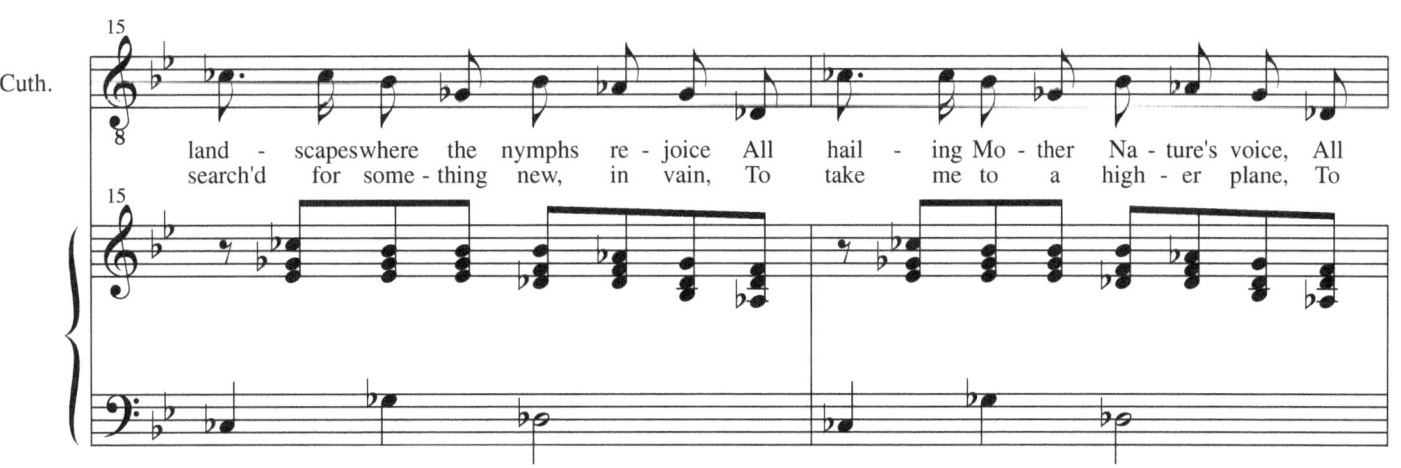

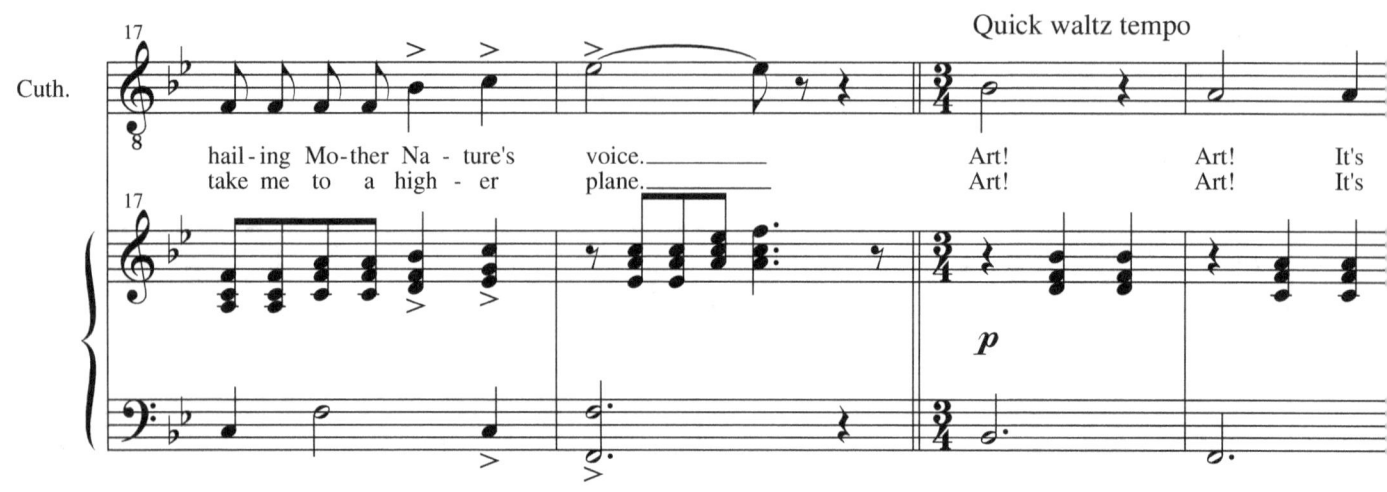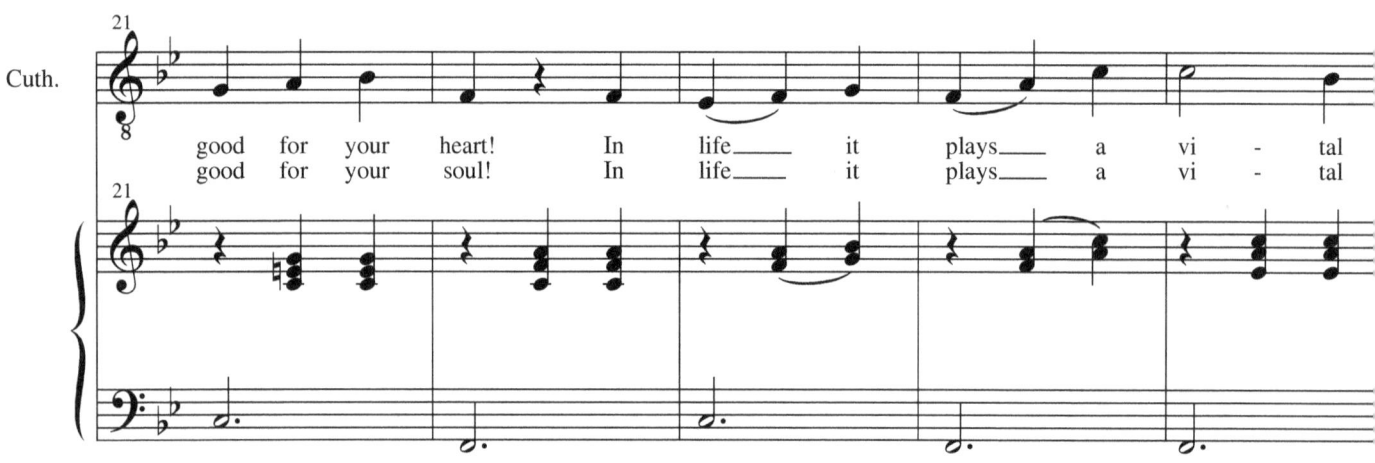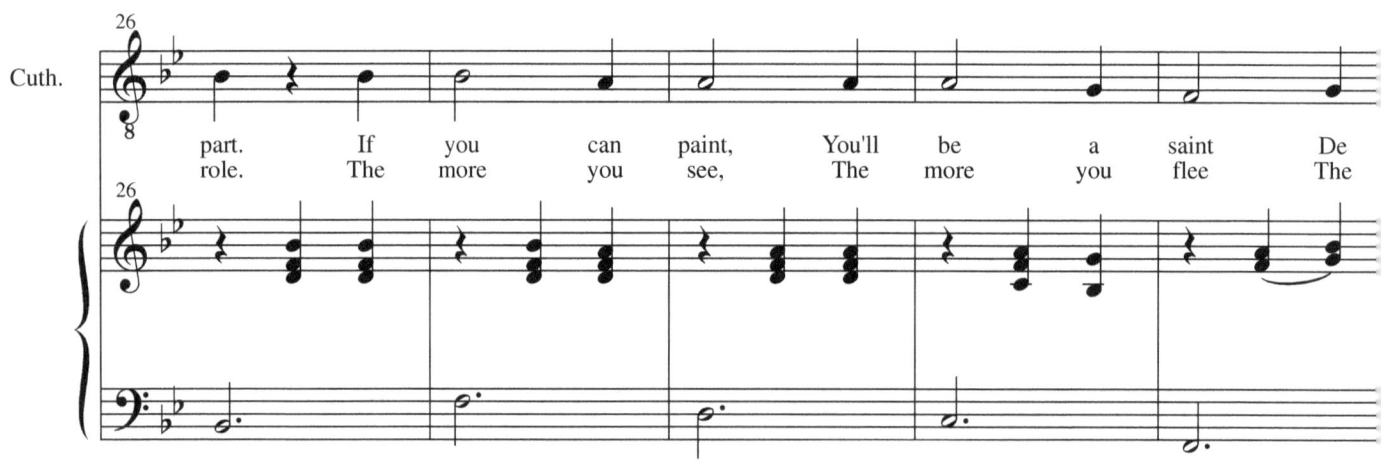

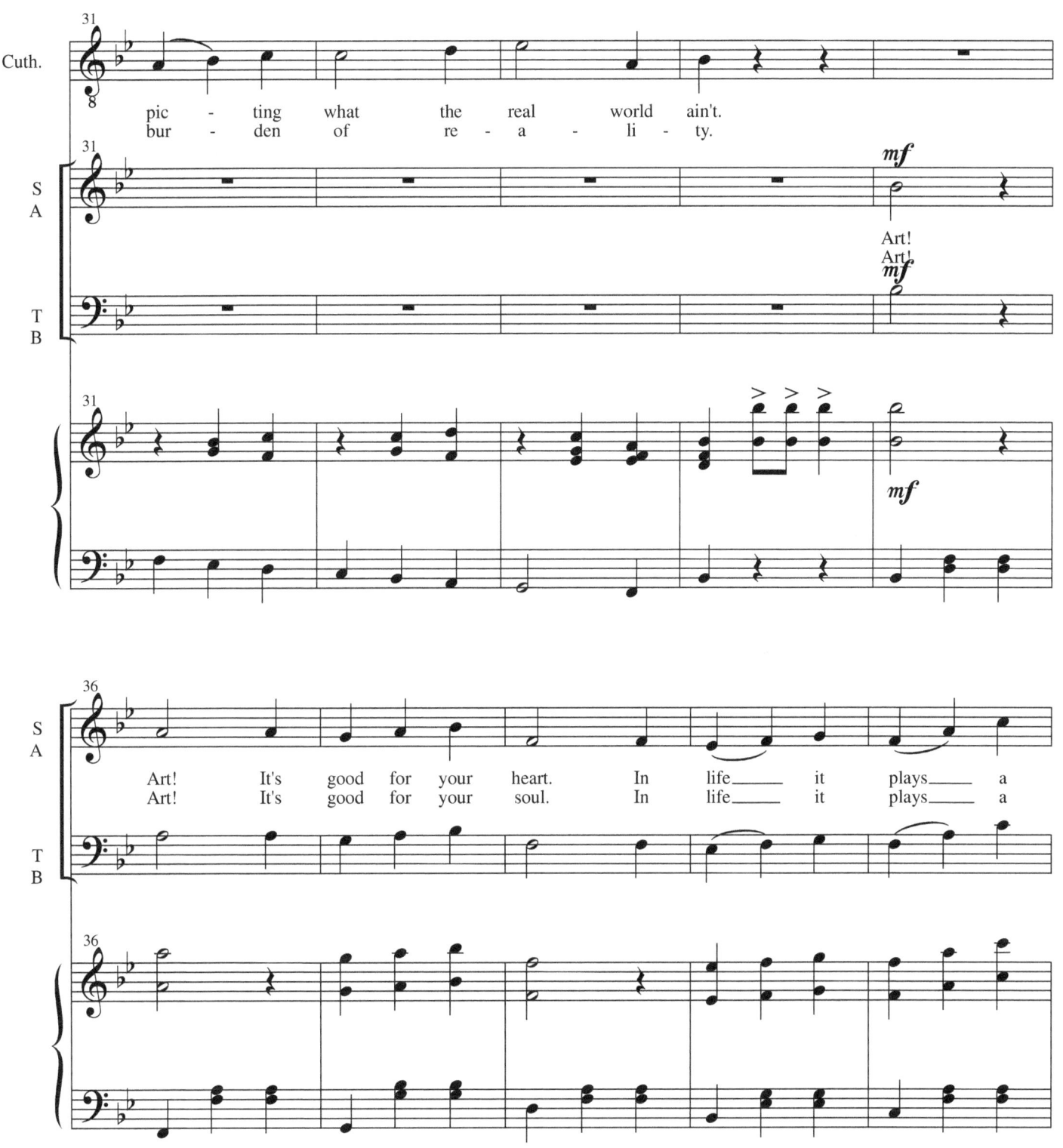

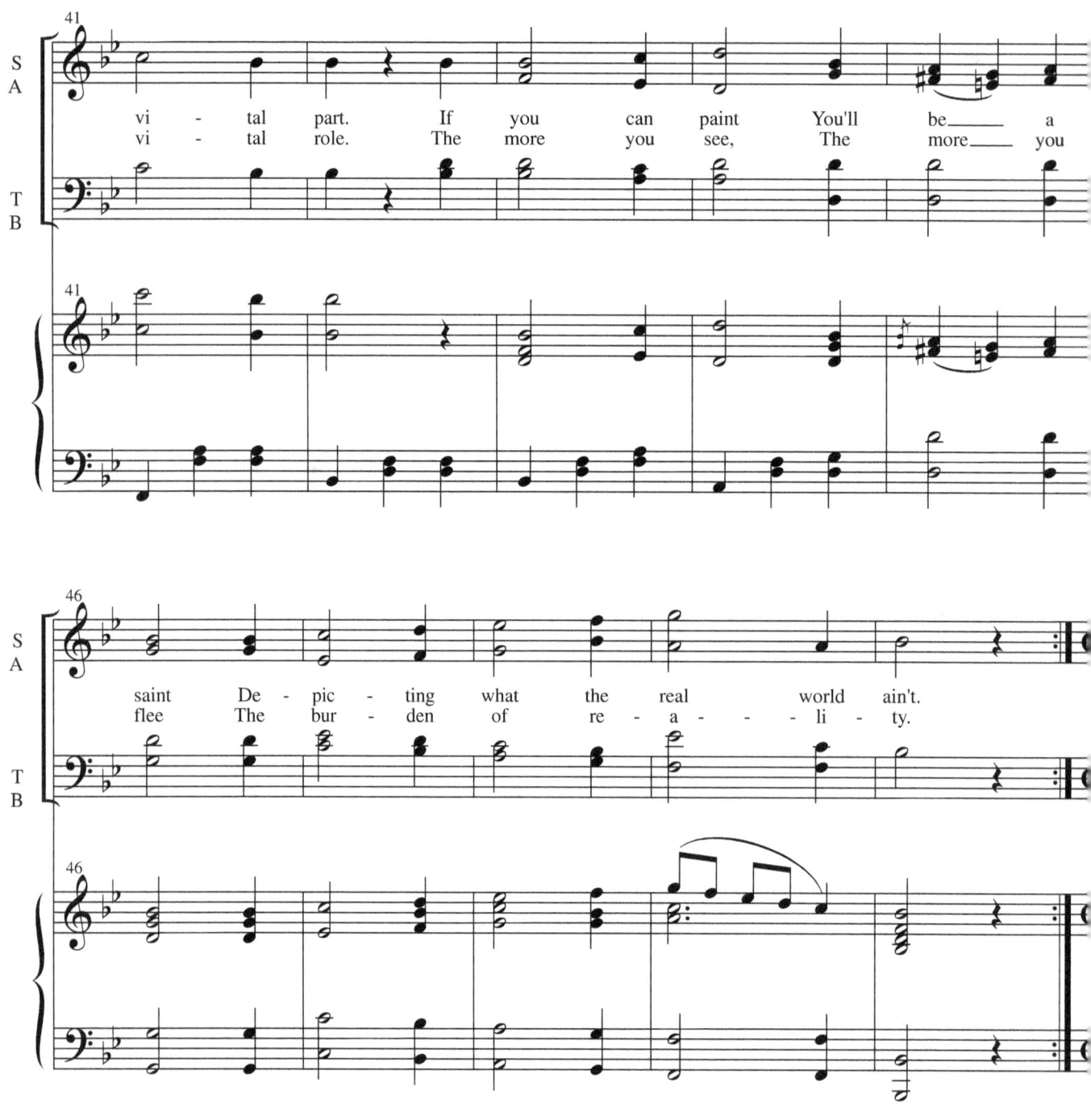

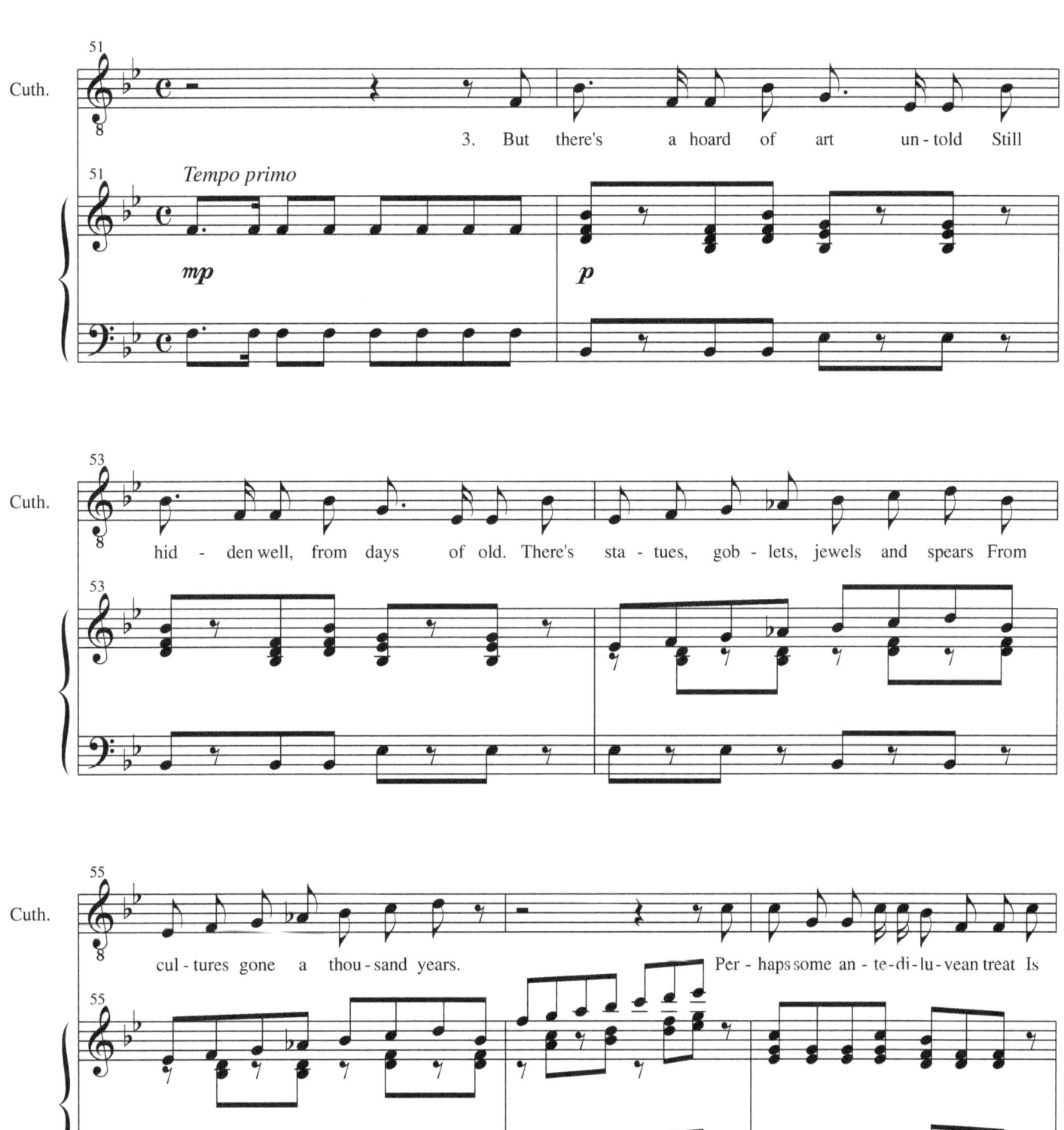

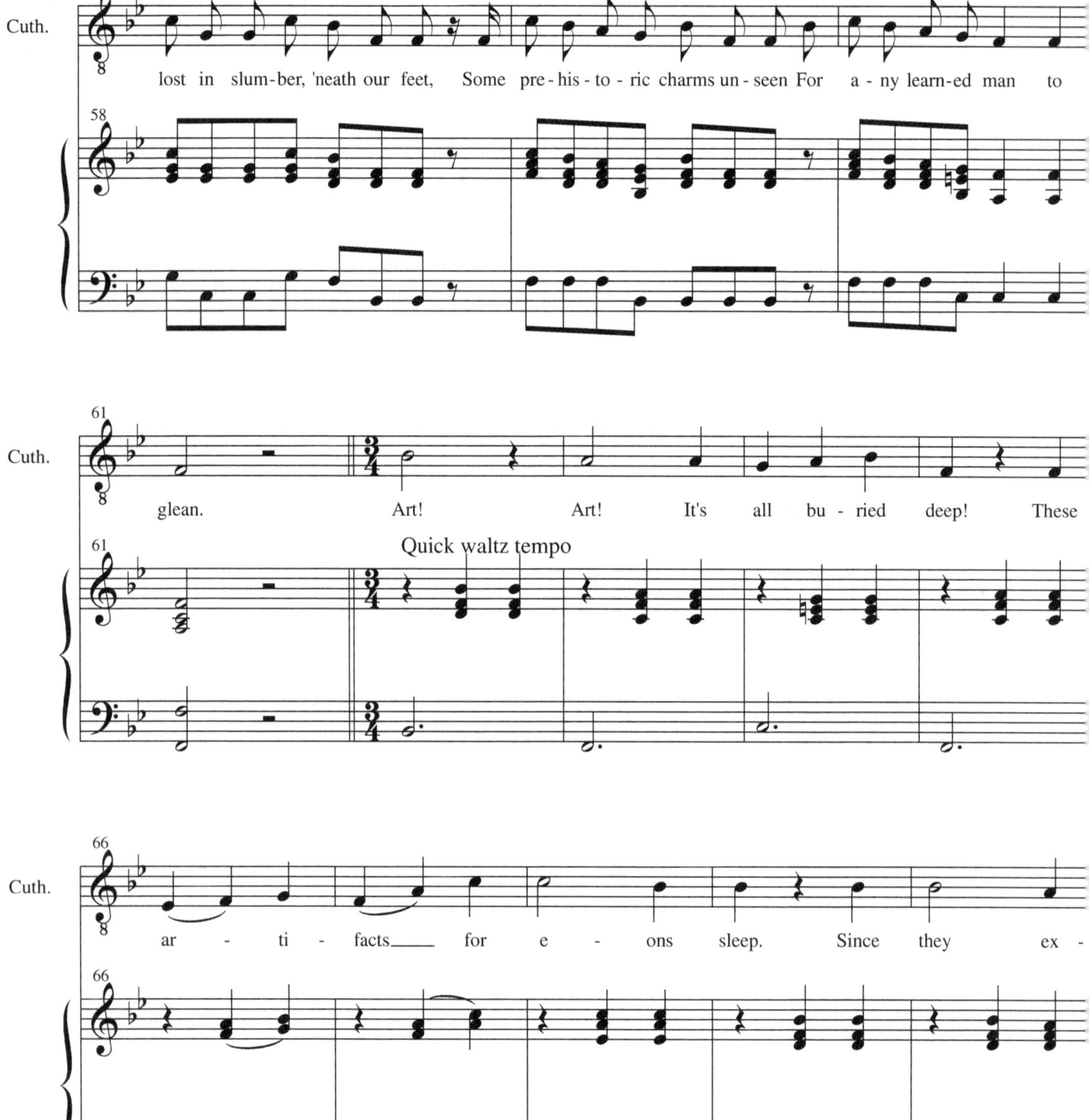

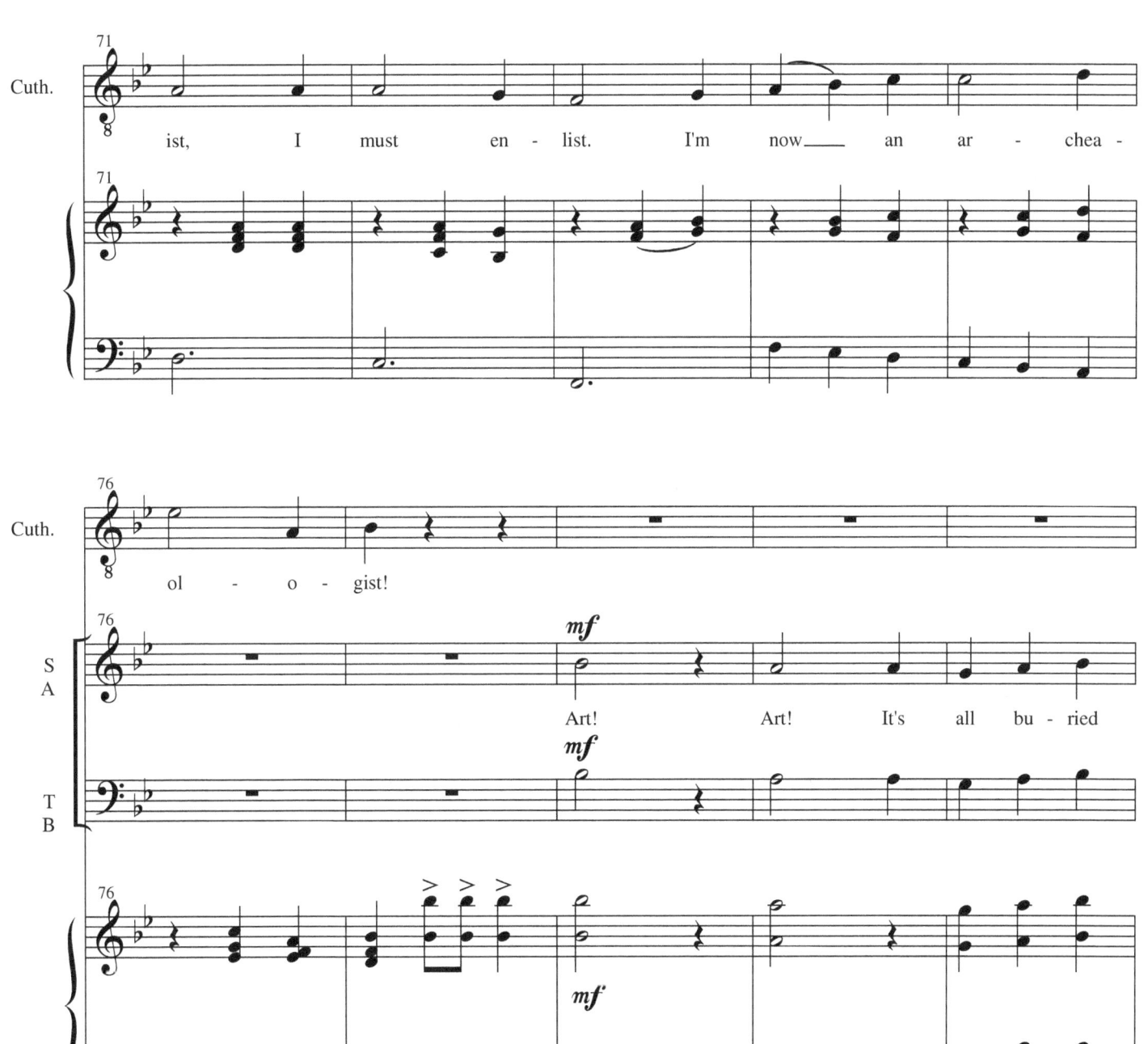

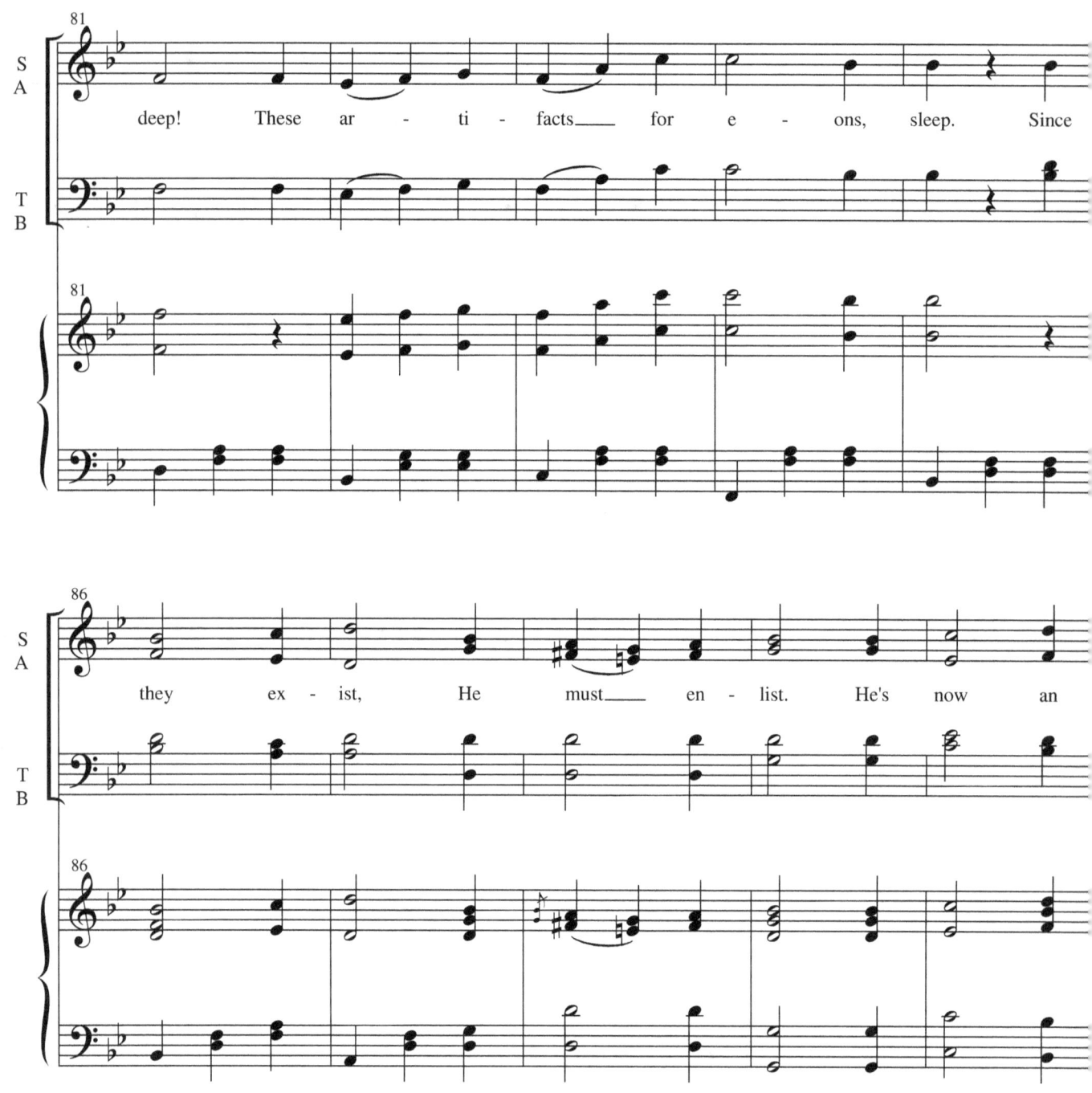

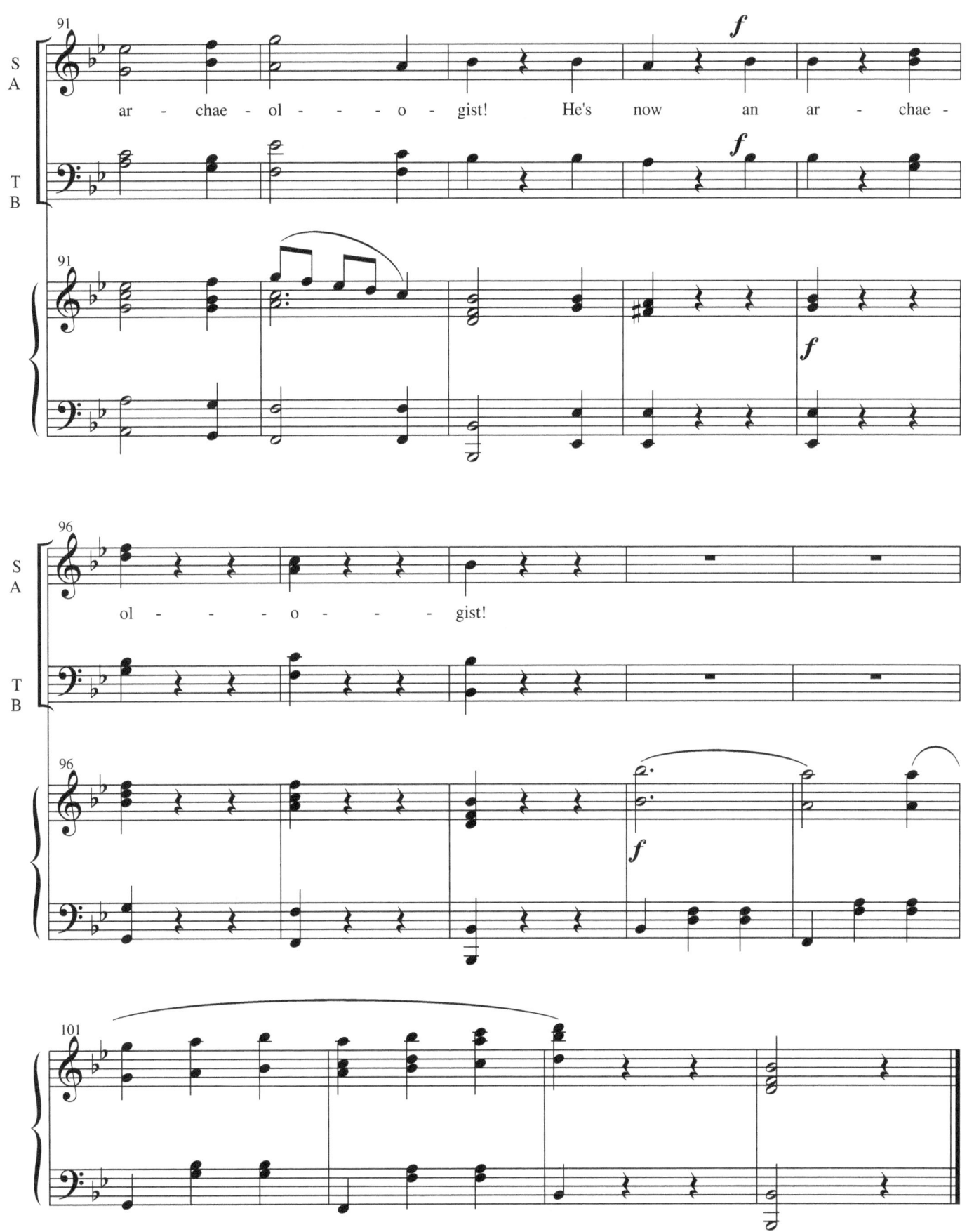

If you enjoyed this work, you may also like the following from the author:

<u>The Final Savoy Operas: A Centenary Review</u>
Available exclusively on Lulu.com in print and e-book formats

The Mountaineers, a romantic light opera in three acts
by Guy Eden and Reginald Somerville
Available exclusively on Lulu.com in print format only.

Two Merry Monarchs, a comic opera in two acts
Libretto by Arthur Anderson, George N. Levy and Hartley Carrick
New Music by Scott Farrell
Piano-vocal score and band parts available.

Sacred work: *Magnificat in C Major*
For SSATB Choir and Soloists
Available exclusively on Lulu.com.

Lindarella's List, a comic opera in one act
Libretto by John Spartan
for six voices and B-flat clarinet and piano
Piano-vocal score only.

Pardon the Intrusion, a farce in one act
Libretto by Andrew Crowther.
Piano-vocal score only.

Clarinet Suite
In six movements for Clarinet Choir
Available exclusively on Lulu.com

If you have comments or questions about performing any of the above works, or about this score, email me at
SCOTTLFARRELL@yahoo.com.

www.ingramcontent.com/pod-product-compliance
Lightning Source LLC
Chambersburg PA
CBHW081051170526
45158CB00006B/1934